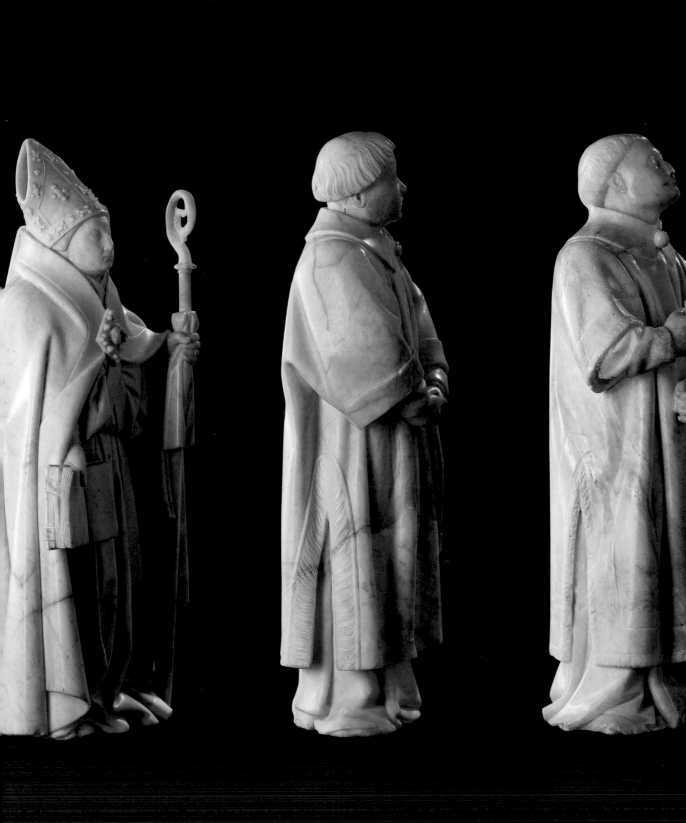

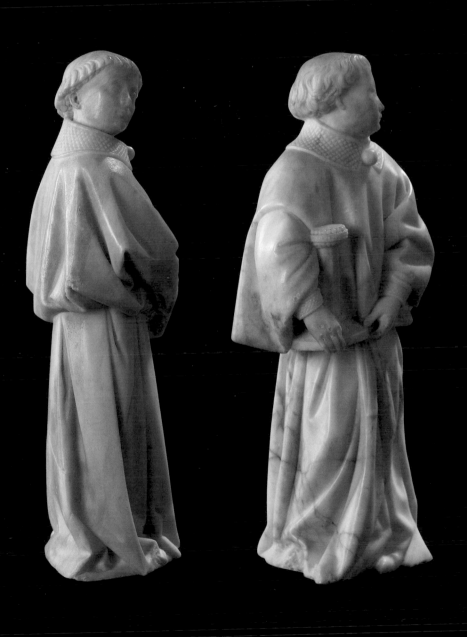

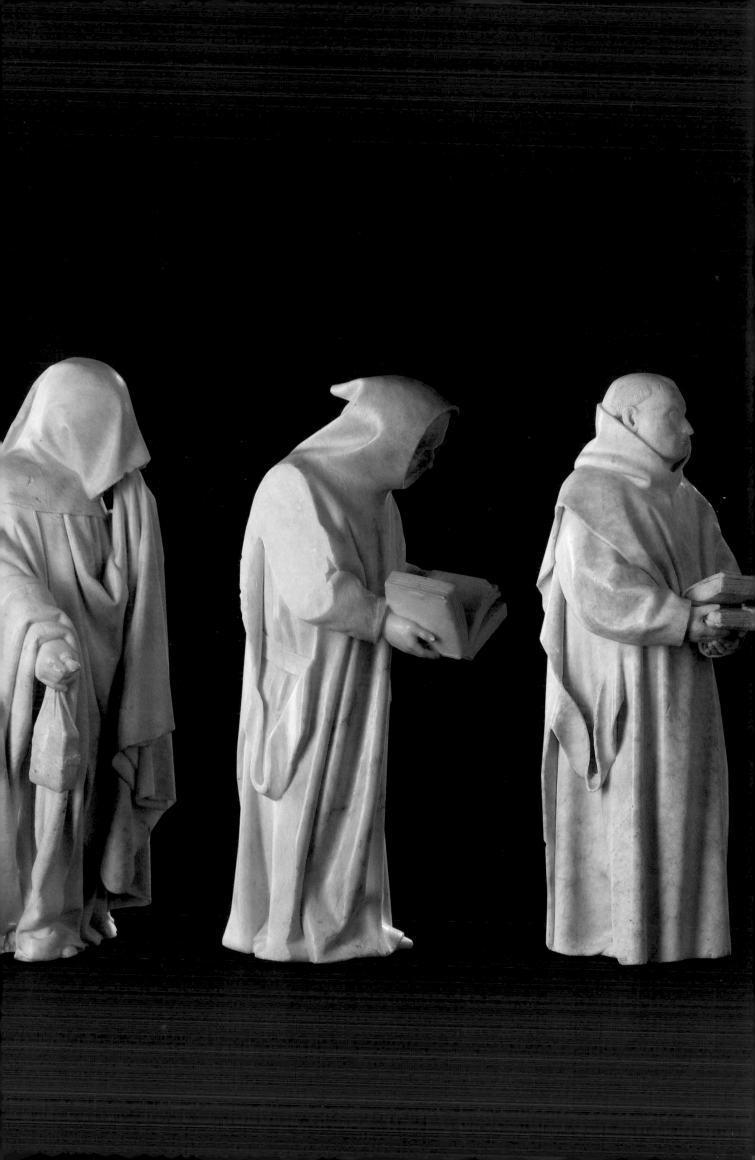

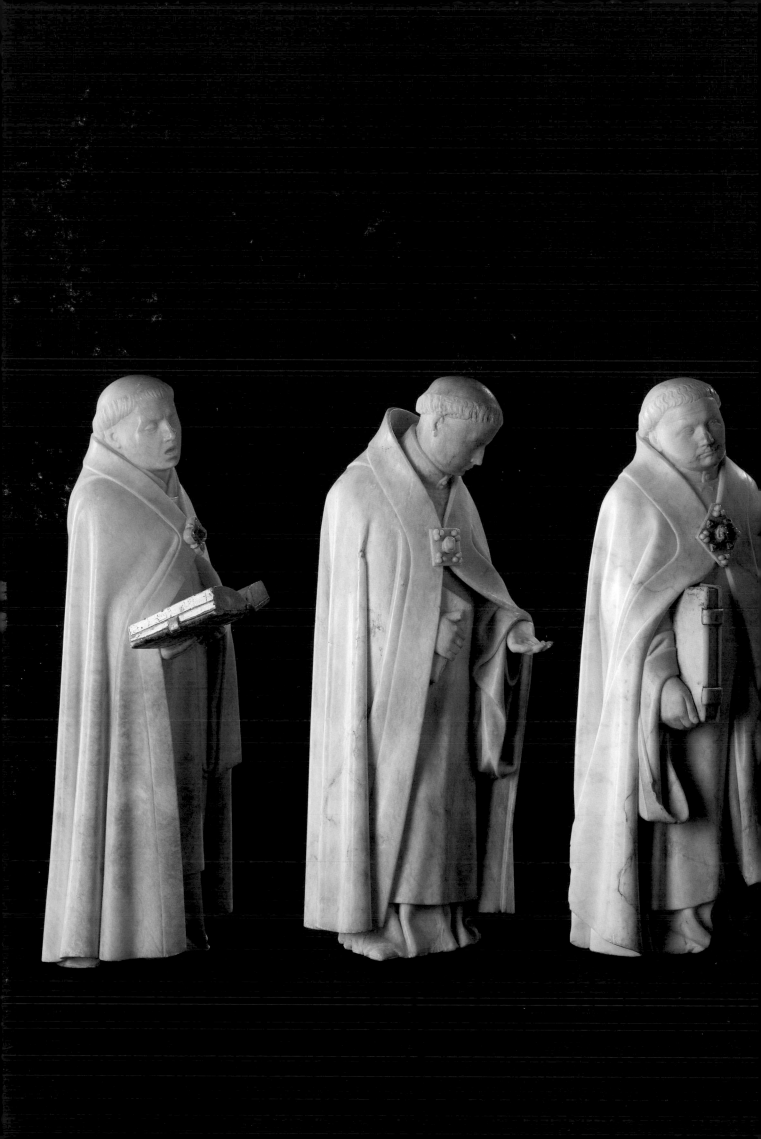

THE MOURNERS

Tomb Sculptures from the Court of Burgundy

Sophie Jugie

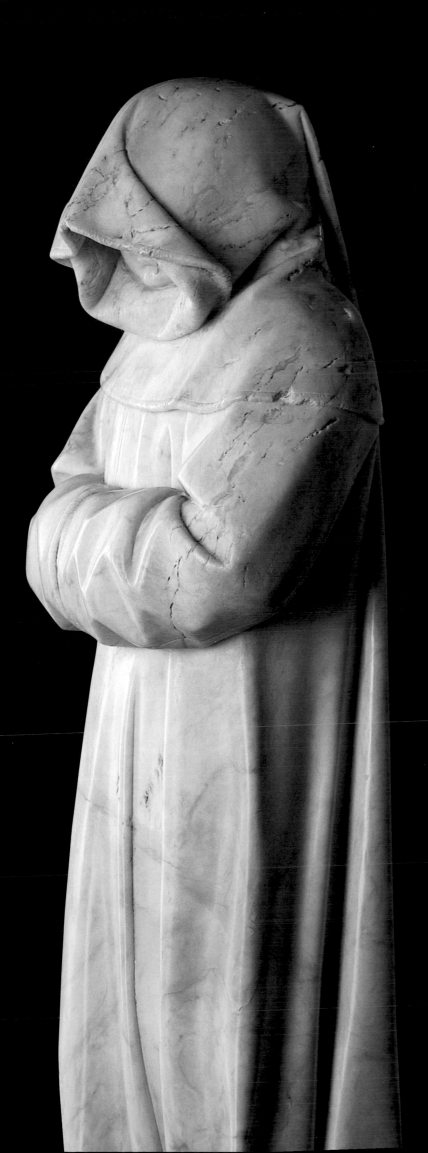

FRAME | THE FRENCH / REGIONAL /
AMERICAN MUSEUM EXCHANGE
Dallas

MUSÉE DES BEAUX-ARTS
Dijon

in association with

YALE UNIVERSITY PRESS
New Haven and London

Published in conjunction with the exhibition *The Mourners: Tomb Sculptures from the Court of Burgundy.*

The exhibition is supported by a leadership gift from the Iris and B. Gerald Cantor Foundation. Additional support is provided by the Florence Gould Foundation, the Eugene McDermott Foundation, Connie Goodyear Baron, and Boucheron. Major corporate support is provided by Bank of the West—Member BNP Paribas Group.

The exhibition is supported by an indemnity from the Federal Council on the Arts and the Humanities.

EXHIBITION ITINERARY

The Metropolitan Museum of Art
March 1 – May 23, 2010

Saint Louis Art Museum
June 20 – September 6, 2010

Dallas Museum of Art
October 3, 2010 – January 2, 2011

Minneapolis Institute of Arts
January 23 – April 17, 2011

Los Angeles County Museum of Art
May 8 – July 31, 2011

Fine Arts Museums of San Francisco,
Palace of the Legion of Honor
August 21, 2011 – January 1, 2012

Virginia Museum of Fine Arts, Richmond
January 20 – April 15, 2012

Musée National du Moyen Age –
Musée de Cluny, Paris
May 20 – September 2012

Published in association with Yale University Press,
New Haven and London www.yalebooks.com

Library of Congress Cataloging-in-Publication Data
Jugie, Sophie.
 The mourners : tomb sculptures from the court of Burgundy / Sophie Jugie.
 p. cm.
 Issued in connection with an exhibition held Mar. 1–May 23, 2010, Metropolitan Museum of Art, New York, and at seven other institutions at later dates.
 Includes bibliographical references.
 ISBN 978-0-300-15517-4 (cloth : alk. paper)
 1. Sepulchral monuments—France—Burgundy. 2. Alabaster sculpture—France—Burgundy. 3. Weepers (Mourners) in art. 4. John, Duke of Burgundy, 1371–1419—Tomb. 5. Philip, Duke of Burgundy, 1342–1404—Tomb. I. Metropolitan Museum of Art (New York, N.Y.) II. Title.

All mourners from the tomb of John the Fearless are from the Musée des Beaux-Arts, Dijon, except no. 67 (see p. 95): Jean de la Huerta (Spanish). *Mourner with a Book from the Tomb of John the Fearless, Duke of Burgundy (1371–1419),* 1443–45. Salins alabaster, 16⅛ × 8 × 4⅞ in. (41.0 × 20.3 × 12.4 cm). The Cleveland Museum of Art. Purchase from the J. H. Wade Fund 1940.129

Pages 2–3, Mourners from the tomb of John the Fearless, left to right: no. 45, see pp. 60–61; no. 44, see p. 59; no. 43, see p. 58; no. 42b, see p. 57; no. 42a, see p. 56

Pages 4–5, Mourners from the tomb of John the Fearless, left to right: no. 51, see pp. 70–71; no. 50, see pp. 68–69; no. 49, see pp. 66–67; no. 48, see p. 65; no. 47, see p. 64; no. 46, see pp. 62–63

Page 7, Mourner no. 56 from the tomb of John the Fearless, see p. 80

Page 14, Mourner no. 48 from the tomb of John the Fearless, see p. 65

Page 16, Mourner no. 52 from the tomb of John the Fearless, see pp. 72–73

Page 54, Mourner no. 53 from the tomb of John the Fearless, see pp. 74–75

Page 116, Mourner no. 68 from the tomb of John the Fearless, see pp. 96–97

Designed by Zach Hooker
Translated from the French by Mark Polizzotti
Edited by Michelle Bolton King
Editorial management and typesetting by
 Marie Weiler
Proofread by Ted Gilley
Photo research by Anne Camuset
Photographs of works in the Musée des Beaux-Arts,
 Dijon, by François Jay
Color management by iocolor, Seattle
Produced by Marquand Books, Inc., Seattle
 www.marquand.com
Printed and bound in China by Artron Color
 Printing Co., Ltd.

123 THE SALLE DES GARDES: BURGUNDY'S
LOCUS MEMORIAE

125 Conclusion

128 Selected Readings on the Chartreuse de Champmol,
the Tombs of the Dukes of Burgundy, and the Mourners

Preface by the Presidents of FRAME

THE TOMBS OF THE TWO GREATEST Dukes of Burgundy, Philip the Bold and John the Fearless, are among the masterpieces of late medieval sculpture in Europe. Commissioned in the fourteenth century for the ducal family's monastic complex outside Dijon, the Chartreuse (Charterhouse) de Champmol, they were moved to the great hall of the ducal palace in Dijon itself after the French Revolution. Since 1799 that noble building has served as the Musée des Beaux-Arts in Dijon. From their installation, these two tombs instantly became the most valuable and important works of art in its collection. Hence, the tombs have moved only once, and the precious collection of mourning monks that perpetually encircle the recumbent rulers have been removed from the ornate arcades of the tombs only to be cleaned and photographed. Like Michelangelo's figures on the Medici tombs in Florence, these figures were designed to be in permanent mourning, never to be part of an exhibition.

FRAME (The French/Regional/American Museum Exchange) is a unique private-public coalition of twenty-four regional museums, twelve each in France and the United States. When the Musée des Beaux-Arts in Dijon joined the coalition four years ago, its director, Sophie Jugie, made the startling proposal that FRAME borrow all forty mourning figures from the tomb of John the Fearless while the museum was undergoing renovation. To a Burgundian, this is the equivalent of the city of Florence sending Ghiberti's bronze doors of the Baptistry to tour American cities—a once in a lifetime opportunity.

FRAME and the City of Dijon announced this unprecedented tour at FRAME's tenth annual meeting in Tours with a truly spectacular series of venues. Because of its international significance, the exhibition will open in America's cultural capital, New York, in the great medieval hall of the Metropolitan Museum of Art. It will then tour to six of the twelve FRAME member museums in the United States—the Saint Louis Art Museum, Dallas Museum of Art, Minneapolis Institute of Arts, Los Angeles County Museum of Art, Fine Arts Museums of San Francisco (Legion of Honor), and Virginia Museum of Fine Arts in Richmond—before making its final trip back to France, where it will close at the Cluny Museum (Musée National du Moyen Age—Musée de Cluny) in Paris before returning to the ducal palace in Dijon forever. The organization of the exhibition has been undertaken by the Dallas Museum of Art, because Dallas is the "sister city" of Dijon in the United States. Art and diplomacy are once again playing a mutually beneficial role in bringing two cultures, two histories, and two peoples together.

There are more people to thank for arranging this unprecedented loan than there are mourners themselves! But we feel so strongly about the importance of this venture that we want properly to acknowledge the women and men who have worked so hard to make it happen. We must begin with our colleagues, the French and American Directors of FRAME, the recently retired Jacques Vilain and his successor Jean-Hubert Martin in France and Rick Brettell and his right-hand person, Pierrette Lacour

(a Dijonnaise herself!) in the United States. From Dijon, Mayor François Rebsamen and Adjunct Mayor for Culture Yves Berteloot have encouraged Sophie Jugie in her quest to send the mourners to America, realizing that, for many Americans, Burgundy is better known for its wine and Dijon for its mustard than for their illustrious art and history. The Dallas Museum of Art's role in this project has been—and will be—essential, and we want to thank Director Bonnie Pitman and her team for all they have done. We want to single out Tamara Wootton-Bonner, Director of Exhibitions and Publications and this exhibition's coordinator; Gabriela Truly, Director of Collections Management; and Dr. Heather MacDonald, Lillian and James H. Clark Associate Curator of European Art.

In the six other American museums, we want to thank Thomas P. Campbell, Director and CEO, and Dr. Peter Barnet, Curator of Medieval Art at the Metropolitan Museum of Art; Brent R. Benjamin, Director, and Dr. Judith Mann at the Saint Louis Art Museum; Kaywin Feldman, Director and President, and Erika Holmquist-Wall, Assistant Curator, at the Minneapolis Institute of Arts; Michael Govan, Director, and J. Patrice Marandel, Ahmanson Chief Curator of European Art, at the Los Angeles County Museum of Art; John E. Buchanan Jr., Director, and Dr. Lynn Federle Orr, Curator in Charge of European Art, at the Fine Arts Museums of San Francisco; Alex Nyerges, Director, and Dr. Mitchell Merling, Paul Mellon Curator and Head of the Department of European Art, at the Virginia Museum of Fine Arts. In France, we must thank Geneviève Bresc,

head of the Department of Sculptures at the Louvre, for the loan of mourner no. 42b; and Elisabeth Taburet-Delahaye, Director, and Xavier Dectot, Curator, at the Musée National du Moyen Age, for the loan of mourner no. 68.

Of course, FRAME could not manage its work without public and private supporters. All the shared costs for this exhibition were underwritten by a generous group of foundations and corporations. The fundraising for this effort in our current economic climate was a real challenge that was accepted and brilliantly coordinated by Lucy Buchanan, FRAME's fundraising consultant. We are indebted to the Iris and B. Gerald Cantor Foundation for their leadership gift to support this exhibition. Their early financial commitment to the project gave us the confidence to move ahead and has guaranteed its success. In addition, we salute the Florence Gould Foundation, Margaret McDermott, and the Eugene McDermott Foundation for their longstanding support of FRAME. We also thank Connie Goodyear Baron, Boucheron, Compagnie St. Gobain, and Bank of the West—Member BNP Paribas Group for their generous contributions. And finally, we recognize the numerous others for their investment in FRAME and this unique cultural exchange that will enrich the lives of all who experience these masterpieces as they make their journey across America.

Marie-Christine Labourdette and Elizabeth Rohatyn
PRESIDENTS, FRAME | THE FRENCH/REGIONAL/
AMERICAN MUSEUM EXCHANGE

11

Preface by the Mayor of Dijon

THE RENOVATION OF THE MUSÉE DES Beaux-Arts of Dijon has provided a chance to offer American and Parisian audiences a unique opportunity to discover for themselves the celebrated mourners from the tombs of the Dukes of Burgundy.

This extensive and long-awaited renovation is a major cultural undertaking for the City of Dijon—all the more so in that our museum is among the oldest in France, established in 1787 and opened to the public in 1799. By good fortune, it is located in the former ducal palace of the States of Burgundy, a magnificent structure where one can learn the entire history of the region, and that also houses the town hall. The main hall of the palace, where the tombs of Philip the Bold and John the Fearless were reassembled in 1823–25 after their first restoration, is much more than a beautiful gallery with splendid works of art: it is truly a *locus memoriae* for the Burgundy region. Respecting a long-held tradition among the mayors of Dijon, I never miss an opportunity to bring the city's most prestigious visitors to admire the tombs.

The purpose of the museum's renovation, therefore, is both to revive its historic setting and to exhibit more broadly its very rich collections. What distinguishes this particular project, overseen by the architectural firm of Ateliers Lion and by Éric Pallot, chief architect of the Office of Historic Monuments, is that it plays off the palace's multi-layered history by placing the medieval and Renaissance collections in the buildings dating from that same period (since works acquired through the dukes' patronage should naturally be shown in their palace); the collections from the seventeenth and eighteenth centuries in the wing built in the late eighteenth century to house Dijon's drawing school; and the nineteenth- and twentieth-century collections in the wing dating from the mid-nineteenth century. Naturally, we also aim to offer visitors an impeccable level of service and comfort, and to furnish the museum with the requisite technological infrastructure. As such, new offsite storage has been built outside the city center, and the former church of Saint-Étienne, located next to the palace, now provides needed extra space for the museum's scientific, artistic, and cultural pursuits, and for temporary exhibitions.

Because the renovation schedule is staggered in three phases, corresponding to the three main areas of the palace and its collections, at no point will the museum be completely closed. That said, the first phase of construction,

which involves the medieval and Renaissance wings, has mandated temporary closure of the tomb gallery, one of the museum's primary attractions. The tombs themselves cannot be moved and will be off view for three years, but we have detached the mourner statues, thus creating an exceptional opportunity to see them in a different light, individually and independent of their arcades. Visitors to the Dijon Museum can view the mourners from the tomb of Philip the Bold in temporary medieval and Renaissance galleries for the duration of construction.

Rather than including the mourners from John the Fearless's tomb along with them, we have decided to tour this second group as ambassadors of Dijon and Burgundy, and of the renovated museum. We immediately realized that FRAME, of which Dijon has been a member since 2005, would be the ideal partner for this tour, and we are delighted that the American and French executives of FRAME greeted the idea with such enthusiasm. We are also delighted that so many American museums have signed on to show these masterpieces, in such major cities as Saint Louis, Dallas, Minneapolis, Los Angeles, San Francisco, and Richmond. And FRAME has gone one better, since the Metropolitan Museum of Art in New York has agreed to be the first stop, and the Cleveland Museum of Art will be adding its own mourner figure to this presentation. We also attach great importance to the mourners' last stop in Paris, the Cluny Museum, the National Museum of the Middle Ages, as a signal to French and Parisian viewers, and to anyone who appreciates medieval art, that the Dijon museum will soon reopen.

I therefore wish every success to the mourners on their American tour and their final stop in Paris. I once again thank the executives of FRAME and the directors and curators of the museums who have welcomed this exhibition. Naturally I invite all those who have been able to admire the mourners through this exhibition to come to Dijon and rediscover them in their rightful setting, in the arcades of the duke's tomb, in the main hall of the restored palace and the renovated museum.

François Rebsamen
MAYOR OF DIJON
PRESIDENT, GRAND DIJON
SENATOR, CÔTE D'OR

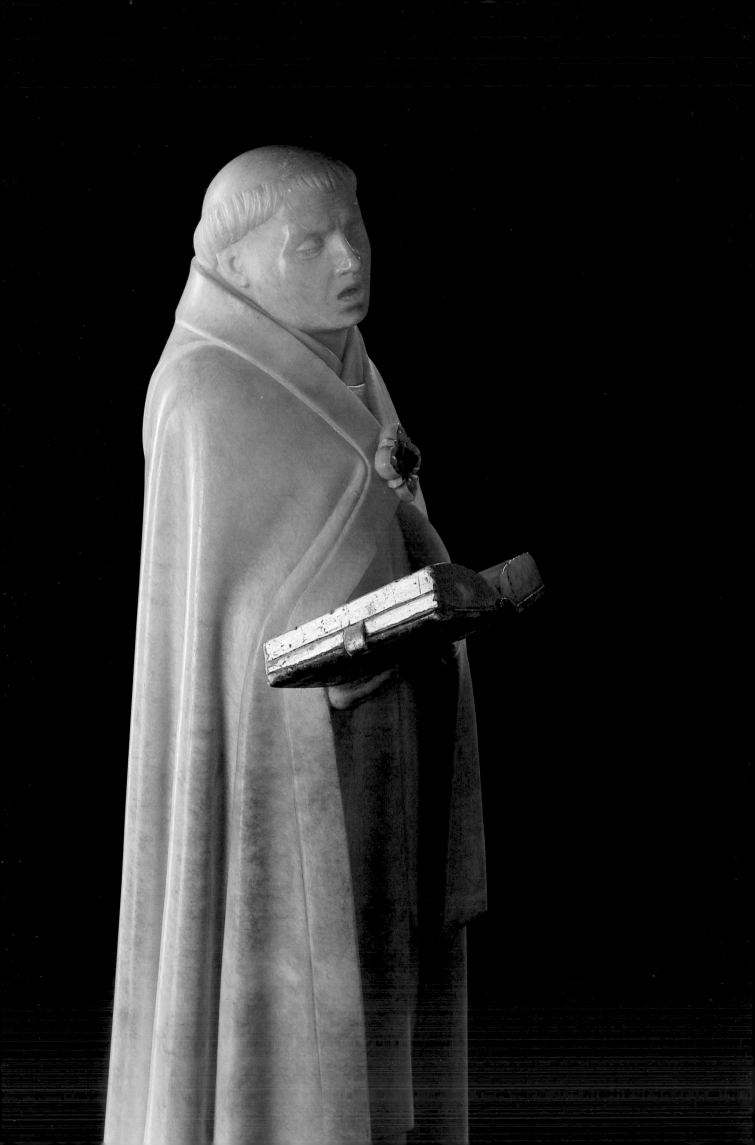

Foreword

IN THEIR PREFACE TO THIS CATALOGUE, FRAME Presidents Marie-Christine Labourdette and Elizabeth Rohatyn point out that the mourning figures on the tombs of the Dukes of Burgundy, now in the Musée des Beaux-Arts in Dijon, were "designed to be in permanent mourning, never to be part of an exhibition." This astute comment offers a good summation of the paradox of museums as places created to house objects that, for the most part, were not made to be shown there—objects whose nature as works of art was secondary to their original function, often to be objects of devotion.

The mourners of the Dukes of Burgundy, no matter how admirably conceived sculpturally and sensitively carved, were not intended to provide aesthetic pleasure, but rather to mourn indefinitely. Their posture and their faces in the shadows of their cowls are designed to convey the pathos of those who were to symbolize an enduring sense of loss at the death of the grand dukes. On the other hand, it is the quality of the execution and the artistry of the figures that ensure that these are successful in their role as mourners in this unending wake, a wake that has not sunk into the maw of forgotten history precisely because of that quality.

The consequence of these figures, now surrounding their tombs in the Dijon museum and no longer in their original resting place in the Chartreuse de Champmol, is that we can apprehend them in their intended role as mourners as well as for their high artistic quality. A further benefit of their conversion to museum property is that they are more easily accessible to a large art-loving public. Thanks to the vision of the local authorities, they are now available to countless enthusiasts on the other side of the Atlantic through this wonderful exhibition organized under the aegis of FRAME.

While I am delighted that many visitors will view these remarkable sculptures at the Metropolitan Museum of Art and at the six FRAME venues on this tour, I should mention that in the end, if I were given a choice—a pure fantasy, naturally—I would probably opt to see them in their original architectural and historical setting, at the Chartreuse de Champmol. But that cannot be, of course. Fortunately, in Dijon, the museum is housed in the ducal palace where the tombs' context is not only apt but quite splendid indeed.

One last word: for me these figures and the tomb complex of the Dukes of Burgundy have a very special and personal resonance as I visited them on more than one occasion as a child. My family had property in the region, and the Dijon museum was *de rigueur* as a stop on our many cultural outings. These figures, slightly frightening for a child, actually, made a deep impression on me. I am thrilled and moved that they should be shown now at the Metropolitan, the museum I have had the honor and privilege to serve for so many years until the end of 2008.

Philippe de Montebello
DIRECTOR EMERITUS,
THE METROPOLITAN MUSEUM OF ART
FISKE KIMBALL PROFESSOR,
THE INSTITUTE OF FINE ARTS, NYU
TRUSTEE, FRAME | THE FRENCH / REGIONAL /
AMERICAN MUSEUM EXCHANGE

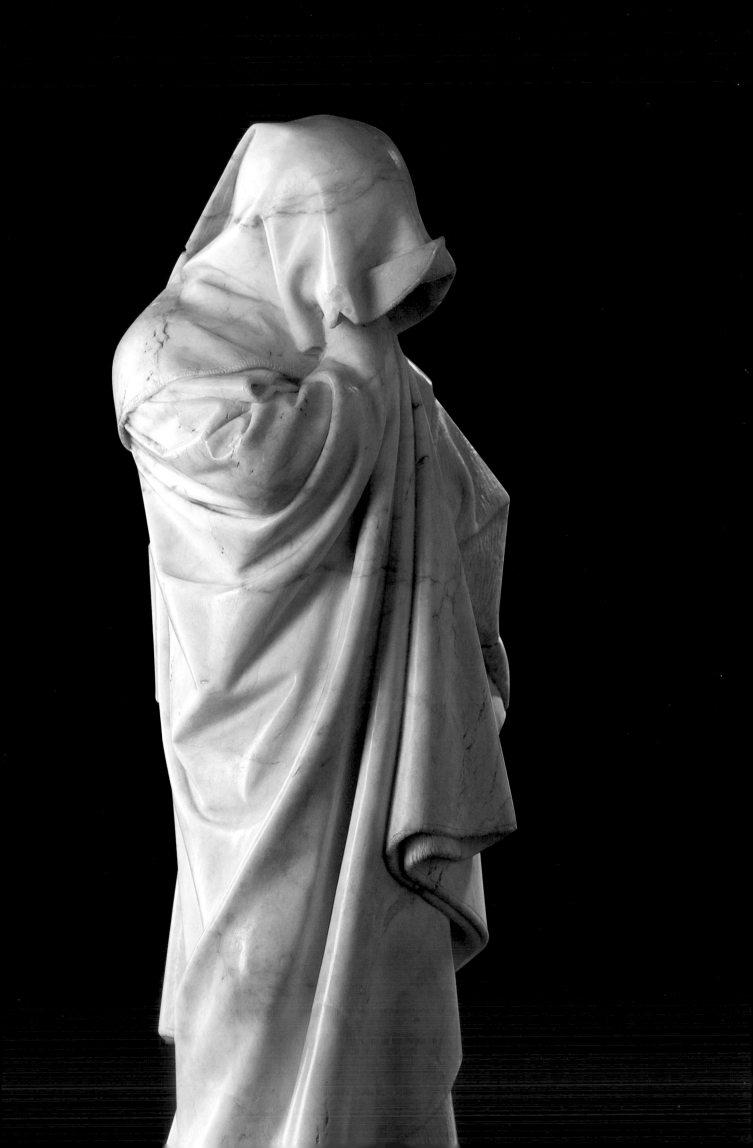

Introduction

THE MOURNERS FROM THE TOMBS OF the Dukes of Burgundy are deeply affecting works of art. Beyond their evident visual and narrative qualities, we cannot help but be struck by the emotion they convey as they follow the funeral procession, weeping, praying, singing, lost in thought, giving vent to their grief, or consoling their neighbor. Mourning, they remind us, is a collective experience, common to all people and all moments in history.

It is precisely this emotional resonance that made these tombs, in their time, not only splendid funeral monuments for a duke and peer of France, but also innovative aesthetic works. Commissioned by Philip the Bold to create his tomb, Jean de Marville, head of the duke's sculpture studio—or possibly Claus Sluter, his collaborator and successor—hit upon the idea of having the mourners circulate in a gallery (whereas in earlier tombs they were confined beneath their arcades) and of giving each figure its own expression of sorrow. Philip's son and successor, John the Fearless, wanted a monument like his father's. For him, sculptors Jean de la Huerta and Antoine le Moiturier created a tomb that very closely resembles his father's: most of the mourners are even exact reproductions of those on the tomb of Philip the Bold.

Because these mourners also bring us into close contact with the funeral of a great prince from the end of the Middle Ages, we must try to place them in context. In the following pages, therefore, I discuss the world of the Dukes of Burgundy and its historical and artistic significance; the Chartreuse de Champmol (Charterhouse of Champmol), which Philip the Bold founded to house his tomb—for while it was being built, the charterhouse was one of the great artistic centers of the late Middle Ages; and the genesis and description of the tombs themselves. I also examine the theme of mourners in medieval funerary art, with illustrations of the entire group of mourners from the tomb of John the Fearless. Finally, I discuss the dismantling and partial destruction of the tombs during the French Revolution, their restoration in the nineteenth century (and again in the early twenty-first century), and their installation in the great hall of the ducal palace, which has become in the heart of the Dijon museum a true *locus memoriae* of Burgundy, both transposing and perpetuating the role of "memorial site" that the tombs were intended to play.

Sophie Jugie
DIRECTOR,
MUSÉE DES BEAUX-ARTS, DIJON

THE DUKES OF BURGUNDY (1363–1477): THE POLITICAL AND ARTISTIC ADVENTURE OF A NOBLE DYNASTY IN THE LATE MIDDLE AGES

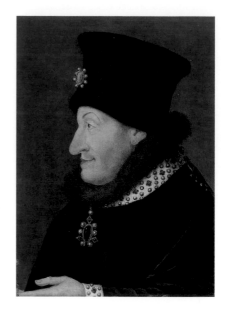

The history of the Duchy of Burgundy in the fourteenth and fifteenth centuries is one of the most fascinating episodes in the history of France, and of Europe in general. Indeed, the Dukes of Burgundy were among the most powerful princes in the Western world: the breadth and economic vigor of their estates provided the wherewithal to support their political ambitions, which went as far as to envision creating a new European kingdom. But we should also mention their penchant for luxury and the major artistic developments that occurred during their reigns—notably in Dijon under Philip the Bold and in Flanders under Philip the Good.

The Four Dukes

The term "Valois Dukes of Burgundy" is applied to princes born of the French royal family, and more specifically the Valois dynasty, which succeeded the Capetians and ruled France from 1328 onward.

Their history begins in 1363, when Philip the Bold, the youngest son of King John II, was bestowed the Duchy of Burgundy, which had returned to the French Crown in 1361 after the death of the last Capetian duke, Philip of Rouvres. It was for his valor at the Battle of Poitiers in 1356, when he warned his father of imminent danger ("Father, to your right! Father, to your left!"), that Philip gained the surname "the Bold."

The dynasty reigned over the duchy for more than a century. Four dukes followed in succession: Philip the Bold (Philippe le Hardi, who reigned from 1363 to 1404; fig. 1), John the Fearless (Jean sans Peur, r. 1404–19; fig. 2), Philip the Good (Philippe le Bon, r. 1419–67; fig. 3), and Charles the Bold, also known as Charles the Rash (Charles le Téméraire, r. 1467–77; fig. 4). The surnames of Philip the Bold's son, John the Fearless, and of his great-grandson,

Charles the Bold—also called Charles the Terrible before the failure of his campaigns earned him the nickname "the Rash"—clearly indicate the place that battle occupied in their lives: the late Middle Ages were troubled by the Hundred Years War between France and England, and by myriad other conflicts between kingdoms, principalities, and cities, even as Turkish advances rekindled desires for a Crusade. This was also the case with Philip the Good, even though his nickname would lead us to expect a prince with a propensity for justice and administration.

A Principality Built between France and the Empire

The Dukes of Burgundy amassed their territory with a mix of determination and practicality. Philip the Bold's marriage in 1369 to Margaret III, Countess of Flanders, gave him the regions (*comtés*) of Flanders, Artois, and what was then named the County of Burgundy (now the Franche-Comté). While Flanders and Artois were already under the French Crown, at the time the Franche-Comté belonged to the Holy Roman Empire. As the brother of French King Charles V and uncle to the future Charles VI,

FIG 1 *Portrait of Philip the Bold*, 16th century, after an original from the end of the 14th century; oil on wood, 16½ × 11 in. (42 × 28 cm); Musée des Beaux-Arts, Dijon, on loan from the Musée National du Château de Versailles.

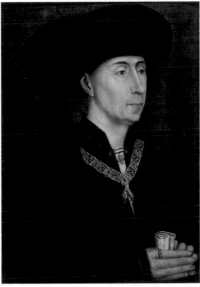
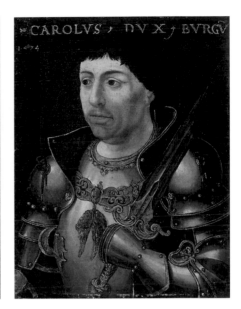

Philip the Bold considered himself above all a Frenchman, and he wielded great political power in the kingdom, first at his brother's side, then as his nephew's regent.

It was in seeking to maintain this influence that Philip's son, John the Fearless, ran afoul of Charles VI's brother, Louis d'Orléans. The rivalry between the two princes dragged the kingdom into civil war. Moreover, both men would themselves fall victim to the war between the Armagnacs and the Burgundians: John the Fearless had Louis d'Orléans assassinated in 1407, while the dauphin (the future Charles VII) had John assassinated in turn on the Montereau bridge in 1419.

Against the backdrop of the Hundred Years War, which had set France against England since the mid-fourteenth century, John's successor, Philip the Good, then sought to form an alliance with the British, only to turn about and pledge allegiance to the king of France. This change of heart was rewarded with important territorial concessions granted him under the Treaty of Arras (1435). One constant of Philip the Good's politics was a desire to expand his domain. Through marriage, inheritance, or purchase, often underscored by military action, he progressively won

dominion over the main principalities of the Netherlands: Brabant and Limburg in 1430; Hainaut, Holland, Zeeland, and Friesland in 1438; and Luxemburg in 1451. Charles the Bold appended the province of Gelderland in 1473. With each addition, the States of Burgundy stretched farther and farther over the Holy Roman Empire. Their power was solidly buttressed: owing to the prosperity of the Dutch cities, which alongside the capitals of Tuscany and Lombardy were the richest in Europe, the dukes' revenues outstripped those of the French king. Moreover, the administration of these territories was highly efficient and in many ways foreshadowed the organization of modern states. The dream of winning these states their independence from the suzerainty of France and the Empire—to give them their own royal crown—was nurtured by Philip the Good, and even more by Charles the Bold. Toward that end, the latter met with Frederick III at Trier in 1473, but ultimately nothing came of these negotiations.

Charles the Bold's efforts to connect Burgundy and the Franche-Comté (the lands "hereabouts") with the Netherlands (the lands "beyond") via military conquest of Alsace and Lorraine, as well as his pretensions to the

throne, were finally recognized as threats by both France and the Empire. Louis XI took advantage of Charles's death at the Battle of Nancy, in 1477, to absorb Burgundy into the French kingdom. That same year, Charles's daughter, Mary of Burgundy, married Frederick III's son, the Hapsburg ruler Maximilian I, and brought the Netherlands and the Franche-Comté into the Austrian dynasty, thus opening a new chapter in European history.

Splendor and Art Serving the Politics of Faith

The remarkable political edifice established by the four successive dukes gave rise to one of the most fascinating artistic and cultural centers of the late Middle Ages. The Court of Burgundy brilliantly showcased the

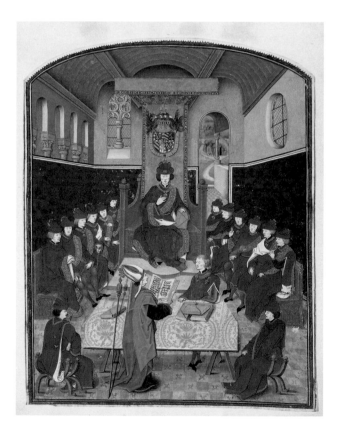

aristocratic lifestyle and images of horsemanship. The four dukes, especially Philip the Bold and Philip the Good, made a great spectacle of extraordinary luxury, attracting artists, musicians, and men of letters, building numerous residences and religious foundations, and in general dazzling their contemporaries with memorable displays of wealth. Beyond the princes' personal interest in the arts, this splendor was a way of advertising their power and establishing their prestige.

In an initiative typical of their politics, which stressed aristocratic ideals and luxury, Philip the Good founded the Order of the Golden Fleece in 1430 (fig. 5). This association, intended to restore chivalrous and Christian values, to revive the Crusades, and thus to federate the nobles of the prince's estates under his service, consolidated the Duke of Burgundy's power. Soon after the fall of Constantinople at the hands of the Turks, Philip the Good and the members of his court announced plans for a Crusade at the banquet of the Vœu du Faisan in Lille in 1454, a ceremony so lavish that it has remained the gold standard of the genre. A source of fascination even today, the Golden Fleece remains the epitome of splendor and of the ideals of the Burgundy court.

The founding of the Chartreuse de Champmol and the creation of the tombs should be understood within this context, as a manifesto of the ducal dynasty—that is, as an expression of both a political agenda and sincere religious conviction.

Dijon: Capital of the Dukes of Burgundy

Like most medieval potentates, the dukes were constantly traveling, and resided only rarely in Dijon. Depending on the prince and the period, these residencies ranged from about forty days a year (Philip the Bold in the 1360s) to a mere two visits (Charles the Bold, in 1461 and 1474). Nevertheless, Dijon was indeed their capital. John the Fearless, Philip the Good, and Charles the Bold were all born in the ducal palace. Philip the Bold, in establishing the Chartreuse de Champmol, created a necropolis for his family: the first three dukes were buried there, and only

FIG 5 *Charles the Bold Presiding over a Chapter of the Golden Fleece,* illumination from *Troisième Livre de la Toison d'Or* by Guillaume Fillastre; Bibliothèque Municipale, Dijon.

historical circumstance prevented Charles the Bold from joining them. The event known as the "Joyeuse Entrée," the ceremonial first visit during which the new duke took possession of the duchy, was a grand affair; Charles the Bold's celebration in 1474, which ran for several days, remains in the annals as the most luxurious of all.

Once in possession of the Duchy of Burgundy, Philip the Bold firmly established Dijon as its capital. It was there that he located the headquarters of his administration for the lands "hereabouts": the Council Chamber, the Accounting Office, the Treasury of Deeds, and a mint. So that he could live there in style, he ordered the construction of the ducal palace, on the site already occupied by the urban palace of the Capetian dukes, and continued building the palace chapel. Only the Tour Neuve (new tower) remains, erected around 1365 by the master builder Belin de Comblanchien and now called the Tour de Bar. But in their day, the buildings around the courtyard and farmyard were numerous, comfortable, and sumptuously appointed. Regardless of whether the duke was in residence, the nobles of his entourage, the caretakers of his mansion, and the artists in his service remained in Dijon. Although he himself was usually absent, his administration, his palace, and his sepulcher indicated that the center of his power was located there.

It is no coincidence that Philip the Good established the headquarters of the Order of the Golden Fleece in Dijon, in the chapel of the ducal palace. He, too, considered Dijon "the primary and most notable city in our duchy of Burgundy," declaring his wish "by the grace of our blessed creator" to "retire there in his old age."[1] Accordingly, Philip rebuilt the palace kitchens, which to this day remain a rare example of this type of structure; furthered the construction and ornamentation of the palace chapel, which around that time was designated a holy chapel through the gift of a blessed host by Pope Eugene IV; and, most importantly, erected a new ducal palace, which is still largely intact despite subsequent modifications. Its most remarkable feature is the great hall, which was built to hold the feasts of the Burgundy court, and which today houses the dukes' tombs.

The Dukes and Their Artists

Two periods stand out artistically as well as politically. The first concerns the development of French art. Philip the Bold was a collector, as were his brothers Charles V, King of France; John, Duke of Berry; and Louis, Duke of Anjou. Among the most splendorous signs of these princes' wealth were the Château of Vincennes, near Paris, built by Charles V, the *Very Rich Hours* of the Duke of Berry, one of the most richly illuminated manuscripts of the Middle Ages, and the *Apocalypse* tapestry of Angers, woven for Louis of Anjou.

Like his brothers, Philip the Bold lived much of the time in Paris. There he acquired rare manuscripts, precious metals, clothing, and tapestries, and also recruited the architects, sculptors, and painters who would work for him. In the late fourteenth and early fifteenth centuries, Paris was in full artistic ferment, a place where artists and dealers flocked, attracted by the presence of the royal and princely courts. Italian dealers were especially numerous, as were artists from Northern Europe, natives of Flanders, Artois, Brabant, Hainaut, Limburg, and Holland, often grouped under the rubric "Flemish." But their number in the service of the Duke of Burgundy was especially high, owing to the duke's direct connections with Flanders and his access to the artists working for his father-in-law, Louis de Mâle. The duke's account books contain the names of the painters Melchior Broederlam, Jean de Beaumetz, Jean Malouel, and Henri Bellechose; and the sculptors Jacques de Baerze (active in Termonde), Jean de Marville, Claus Sluter (a native of Holland), Claus de Haine from Tournai, Jean de Prindale, and Claus de Werve (also from Holland).

Philip the Bold had residences in Paris, Flanders, Artois, and Burgundy. In his duchy, he owned a number of castles, and lived mainly in Montbard, Rouvres-en-Plaine, Argilly, and Germolles, the home of his wife Margaret, as well as in his palace in Dijon. It was also in Dijon that he established the Chartreuse de Champmol as a mausoleum for his dynasty. As such, it was in Dijon that the architects, painters, sculptors, cabinetmakers, and others

in the duke's service lived. There they worked on both the charterhouse and the duke's residences, all of which have sadly been destroyed with the exception of Germolles and the palace in Dijon. They crossed paths with colleagues from Burgundy or the Franche-Comté. While some stayed in Dijon a relatively short time—the duration of a single project—others took up long-term residence, making the capital of the Dukes of Burgundy a veritable artistic center in the age of Philip the Bold. The creations executed for the duke are fully consistent with the art of the French court around 1400, the period sometimes characterized as International Gothic; but the contributions of the northern artists, and the strong personalities of Claus Sluter and of his nephew and collaborator, Claus de Werve, would have a significant impact on the Burgundian school of sculpture in the fifteenth century, steering it toward a more realistic and powerful treatment of figures. From that point on, the story of sculpture in Burgundy would parallel the story of the sculptors in the duke's service.

During the time of Philip the Good, however, the political and artistic center of gravity of the States of Burgundy shifted to the Netherlands. Under the influence of Jan van Eyck, Robert Campin, and Rogier van der Weyden, painting underwent a true revolution, calling renewed attention to the depiction of the real world. Tapestries and carved wooden altarpieces enjoyed a remarkable rise in popularity and were exported throughout Europe. Philip the Good, who most often lived in Bruges, Ghent, or Brussels, greatly prized these innovations, and so, therefore, did the members of his court. It was thus in Flanders that the innovative artistic center of the States of Burgundy came to be located. While the duke hardly neglected Burgundy or Dijon, which remained the capital of his states, his infrequent presence there did not justify maintaining a permanent workshop and a retinue of master craftsmen. Dijon and Burgundy still kept up a solid artistic output, but on a more regional level. When Philip the Good went to commission his father's tomb, he had some difficulty finding sculptors who could handle such a complex undertaking. At least he was able to endow the charterhouse with a work by Van Eyck.

THE CHARTREUSE DE CHAMPMOL

The Foundation and Selection
of the Carthusian Order

Like any great ruler, Philip the Bold was expected to display his religious devotion and to make arrangements for his sepulcher. He also intended to proclaim the implantation of the new dynasty in Dijon, the capital of his duchy, breaking with the tradition established by the Capetian dukes, who were buried in Cîteaux. He therefore needed to create a religious foundation. Philip settled on the Carthusian order, which at the end of the fourteenth century enjoyed the favor of the rich and powerful.

Founded in 1084 by Saint Bruno in the Grand Chartreuse range of the Alps, the order practiced a particularly austere form of monasticism. The Carthusian monks, numbering twelve or twenty-four, lived in individual houses, where they prayed, worked, took their meals, and slept. They left these dwellings only for daily Mass and for moments of communal activity on Sundays and holidays. The fathers were assisted in material matters by lay brothers. Isolated from everyone, the Carthusians were joined to their fellow men by their prayers for intercession on behalf of all humankind. As such, the austerity of their reclusive life and their devotion to silence, contemplation, and penitence offered the prince the best guarantees of their prayers' effectiveness, for himself, his family, and his duchy.

In 1378, Philip the Bold acquired the domain of Champmol, west of Dijon, on the northern banks of the river Ouche, which tended to flood the surrounding fields: the name Champmol literally means "soggy plain." The cornerstone of the charterhouse was solemnly laid by the duchess in 1383, and the foundational charter, which provided for twenty-four Carthusians assisted by five lay brothers, was dated 1385. In his will of 1386, Philip the Bold asked to be buried in Champmol in Carthusian robes. In 1388, the church was dedicated to the Virgin and the Trinity, and the monks took up residence. The final structures were probably completed about 1410, when the tomb of Philip the Bold was installed in the chancel.

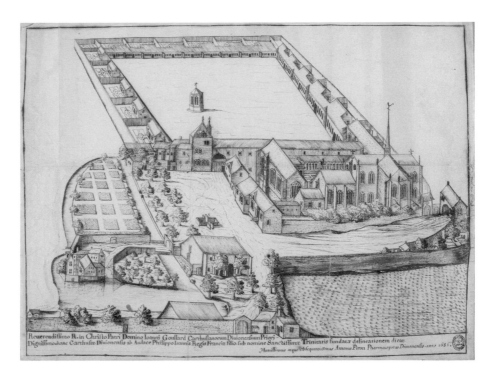

Reuerendiſſimo R. in Chriſto Patri Domino Ioanni Goullard Carthuſianorum Diuionenſium Priori
Digniſſimo:hanc Carthuſiæ Diuionenſis ab Audace Philippo Ioannis Regis Franciæ filio ſub nomine Sanctiſſimæ Trinitaris fundatæ delineationem dicat
Humillimus atque obſequentiſſimus Amatus Piron Pharmacopœus Diuionenſis anno 1685.

For more than twenty years, the duke would devote considerable amounts of money to building and decorating the charterhouse, as well as to acquiring landed estates that, until the Revolution, would ensure the establishment's prosperity.

The Buildings and the Décor

The charterhouse was destroyed during the French Revolution, but we can re-create it from ruins still in place, from several descriptions and renderings predating its demolition (fig. 6), and especially from building invoices conserved in the dukes' archives (Archives Départementales de la Côte d'Or, Dijon). These documents establish with fair precision the timetable of the work done and the identity of those who did it. Architects, sculptors, painters, cabinetmakers, metalworkers, glassworkers, and tile glazers from Burgundy, France, Flanders, Germany, and even Spain participated over the course of several decades in the building and decoration of the charterhouse.

The building site was first overseen by Drouet de Dammartin, assistant to Raymond du Temple, the architect who designed the Louvre for King Charles V, and the brother of Guy de Dammartin, architect to the Duke of Berry. It was he who drew up the plans for the charterhouse and followed the progress of its construction in the 1380s. The sculpture studio, headed successively by Jean de Marville from 1372 to 1389, Claus Sluter from 1389 to 1406, and Claus de Werve from 1406 to 1439, created the ornamental sculpted decorations, the statues on the church portal (1388–1401), on the various altars (1390s), and on the Well of Moses (1396–1405). The painting studio, run by Jean de Beaumetz from 1376 to 1396, Jean Malouel from 1396 to 1415, and Henri Bellechose from 1415 to 1445, provided both mural and panel paintings. In addition, certain wooden altarpieces were commissioned and executed in Flanders, including the *Altarpiece of the Crucifixion* (fig. 7) and the *Altarpiece of Saints and Martyrs* (fig. 8), which were carved by Jacques de Baerze in Termonde and painted and gilded by Melchior Broederlam in Ypres (1390–99), then

FIG 6 Aimé Piron (1640–1727), *View of the Chartreuse de Champmol,* 1686; Bibliothèque Municipale, Dijon.

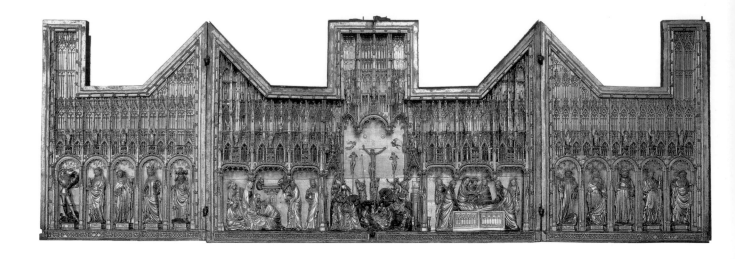

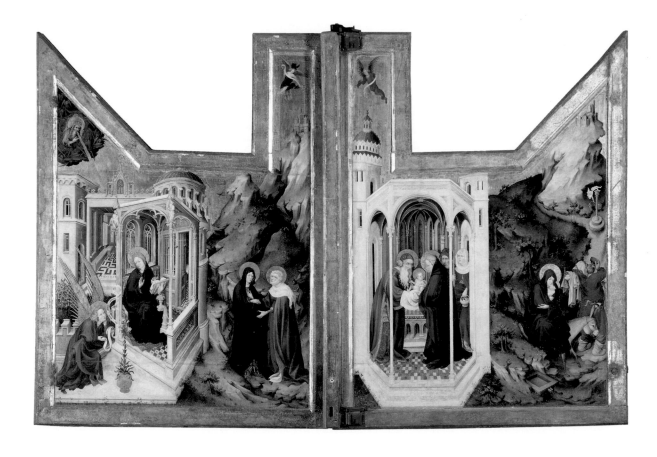

FIG 7 Jacques de Baerze
(fl. before 1384–after 1399) and
Melchior Broederlam (fl. 1381–1409),
Altarpiece of the Crucifixion, 1390–99;
carved and gilded wood, oil on wood,
middle: 65¾ × 99¼ in. (167 × 252 cm),
wings: 65¾ × 49¼ in. (167 × 125 cm);
Musée des Beaux-Arts, Dijon.

top: wings open
bottom: wings closed

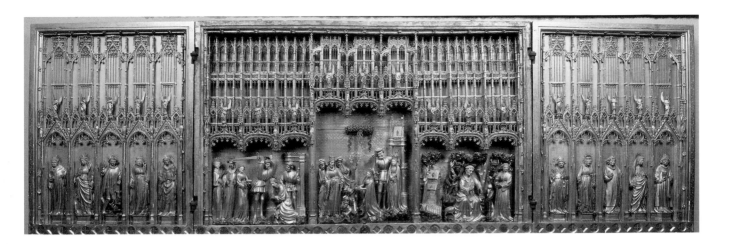

delivered to the charterhouse. Alongside the painters and sculptors worked cabinetmakers such as Jean de Liège, metalworkers such as Colart Joseph from Dinant, tile glazers such as Perrin de Longchamp and Jean de Gironne, and master glassworkers such as Robert de Cambrai.

The charterhouse, which took some twenty years to complete, was a kind of *Gesamtkunstwerk,* or "total work of art": the architecture, the painted and sculpted decoration, and the furnishings formed a coherent whole, further embellished by precious metals, ivory, liturgical ornaments, and illuminated manuscripts, and enlivened by religious celebrations.

A monumental doorway permitted access to the convent from the Paris road. The very tall church with its single nave and pentagonal apse was painted white, topped with a wooden vault covered with paneling painted blue and gold, with crests and foliage motifs. A horizontal band, decorated with the dukes' armorials, ran along the base of the vault. The main altar was decorated with a carved and gilded altarpiece and surrounded by brass columns hung with curtains. Chandeliers, a tabernacle, and a brass pulpit completed the décor. The chancel was decorated with woodwork, with stalls for the monks and seats for the celebrants; the seats were topped with canopies and their backs featured the coats of arms of Philip

the Bold, Margaret of Flanders, and John the Fearless. A wooden partition separated the monks' chancel from the space reserved for the lay brothers in the western part of the nave. The church contained two false transepts that harbored, to the north, the duke's oratory chapel covering two floors, and to the south, the Virgin's chapel, the sacristy, and the treasury. Two other chapels opened onto the north wing. The lavishly appointed oratory chapel was lined with wood paneling, provided with a fireplace, and decorated with stained-glass windows, statues, carved and gilded altarpieces, and paintings that made conspicuous use of exorbitant pigments such as gold and lapis lazuli. The floor tiles featured hunting scenes, marguerites, genista or broom, and other emblematic motifs, and in front of the altar were blue-and-white ceramic tiles depicting the crests of Burgundy and Flanders. The interior decoration of the church and chapels was completed in 1395.

Leading into the church was a portal (fig. 9) formed of molded arches surmounting an unadorned tympanum, decorated with two trefoil arches above the doors. In this architectural setting were five statues on consoles under canopies: the Virgin and Child on the central pillar, Philip the Bold presented by Saint John the Baptist to the left, and Margaret of Flanders presented by Saint Catherine to the right. The consoles were decorated with two prophets

FIG 8 Jacques de Baerze
(fl. before 1384–after 1399) and
Melchior Broederlam (fl. 1381–1409),
Altarpiece of Saints and Martyrs,
1390–99; carved and gilded wood,
oil on wood, middle: 62½ × 99¼ in.
(159 × 252 cm), wings: 65¾ × 49¼ in.
(167 × 125 cm); Musée des Beaux-Arts,
Dijon.

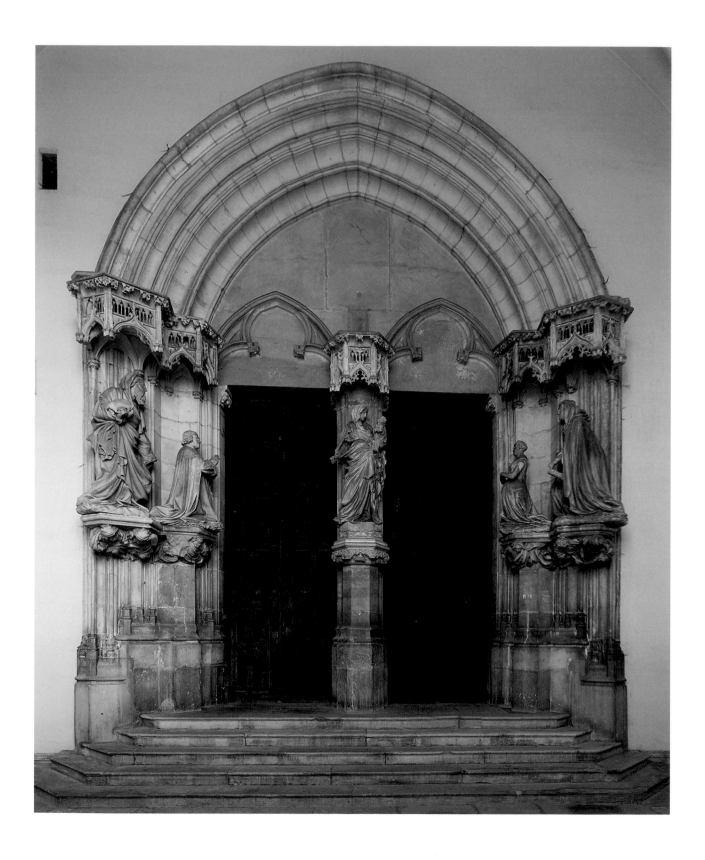

FIG 9 Jean de Marville (?–1389),
Claus Sluter (c. 1360–1406), and
their studio, **Portal of the Church of
Champmol**, 1384–1401; C.H.S de
la Chartreuse, Dijon.

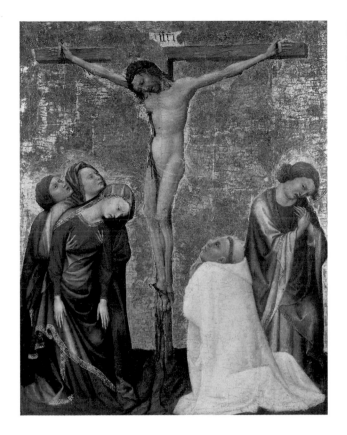

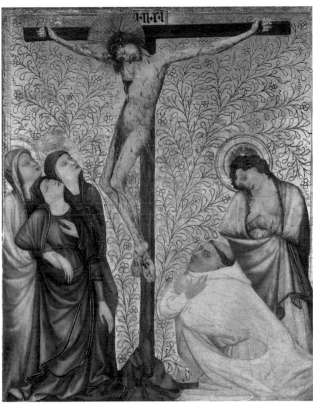

under John the Baptist and two doctors of law under Saint Catherine, and figures bearing crests under the duke and duchess. The stone base under the statue of the Virgin displays the initials of the founders, P and M. The portal is not uniform: the piers and archivolts have been widened. The account books bear this out: while the portal was erected in 1386, an entry from 1390 mentions the "enlargement that Claus ordered done." We can interpret this as a change of mind, by which Claus Sluter modified Jean de Marville's design for a portal with three standing figures into one for five figures: the standing Virgin, the kneeling donors, and the slightly inclined saints. The figures' varied postures, the impression of movement, their fully three-dimensional character, and the realism of the faces confer on the whole a great dynamism and a great independence from the architectural setting. The statues left Claus Sluter's workshop between 1391 and 1393; the canopies were installed in 1401.

Like any charterhouse, the convent contained a small cloister, completed in 1388, with places for communal activities (chapter house, refectory, kitchen, and other administrative buildings) and the prior's apartment (see fig. 6). After this came the large cloister, comprising the monks' cells and their graveyard. To encourage their daily meditations, each cell was furnished with a small panel depicting the Crucifixion with a Carthusian monk, produced by Jean de Beaumetz and his studio. Only two of these are known to have survived (figs. 10 and 11).

At the center of the large cloister is the monument known as the Well of Moses (fig. 12)—though entered in the ledgers as the Great Cross of the charterhouse—created between 1396 and 1405 under the direction of Claus Sluter (sculpture) and Jean Malouel (painting). This unique monument is at once a fountain and a Crucifixion, following Carthusian practice. It can be described in its current

FIG 10 Jean de Beaumetz (fl. 1361–96), *The Crucifixion with a Carthusian Monk,* c. 1389–95; tempera and gold on wood, 23½ × 19 in. (60 × 48.5 cm); Louvre, Paris. Photo: Scala / Art Resource, New York.

FIG 11 Jean de Beaumetz (fl. 1361–96), *The Crucifixion with a Carthusian Monk,* 1390–95; tempera and gold on wood, 22¼ × 18 in. (56.6 × 45.7 cm); The Cleveland Museum of Art, Leonard C. Hanna, Jr. Fund, 1964.454.

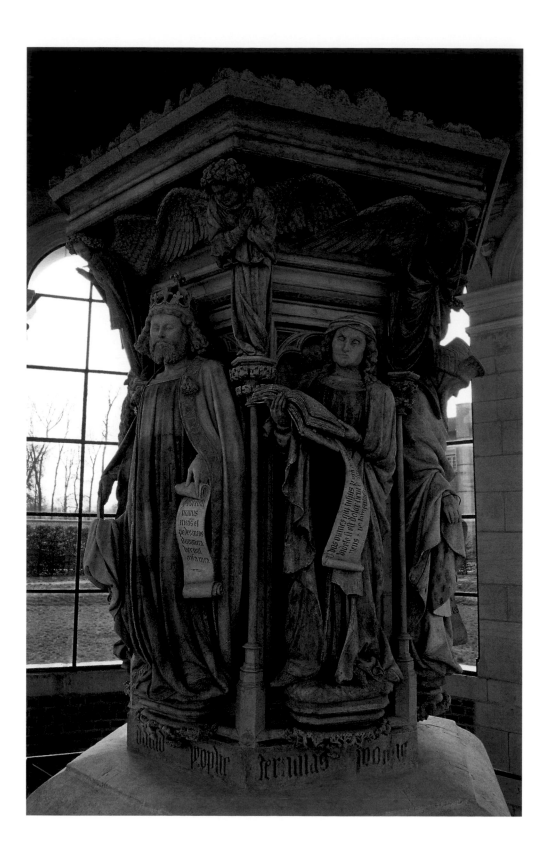

FIG 12 Claus Sluter (c. 1360–1406),
Claus de Werve (?–1439), and their
studio, *The Well of Moses*, 1396–
1405; C.H.S de la Chartreuse, Dijon.

state as a hexagonal pillar emerging from a fountain, surrounded by six figures of prophets—David, Jeremiah, Zechariah, Daniel, Isaiah, and Moses—each bearing a banner or scroll marked with their prophecy announcing the Passion of Christ. Six angels, one between each of them, support the terrace, representing six emotional responses or prayerful attitudes before the Passion. A cross with the figure of Christ (fig. 13) resting on a high column once rose above the terrace. The figure of Mary Magdalene was at the foot of the cross, her arms wrapped around the column. Until recently it was believed that the Virgin and Saint John completed this Crucifixion scene, but a study by Susie Nash suggests that this is untrue[2]—both giving Mary Magdalene increased prominence and underscoring the example that Magdalene, a sinner who withdrew to the desert in repentance, could provide to the Carthusians. Nash notes as well that the cross was facing toward the angel between David and Jeremiah. The figure of David holds a privileged position as an ancestor of Christ and an exemplary king. As for Jeremiah, Nash suggests that his facial features were modeled on those of Philip the Bold, thereby realizing in stone the duke's desire to find a place among the Carthusians. The quality of the sculpture, the beauty and variety of the draperies, the extreme realism of the faces, the exactitude of the accessories on the costumes, the richness of the polychromy, the skill shown in the construction and assembly, and the complexity and loftiness of its theological statement make the Well of Moses a truly exceptional monument—even if its placement in the most private reaches of the cloister ensured that it was seen by the Carthusians alone.

Dynastic and Religious Significance

Upon Philip the Bold's death in 1404, his body was laid to rest in a cellar beneath the church, while his monumental tomb was installed in the chancel, in front of the altar. The charterhouse would later contain the sepulchers of John the Fearless and Margaret of Bavaria, Philip the Good and Isabel of Portugal, and other family members, making it a veritable family mausoleum. The only other monumental tomb, however, was that of John

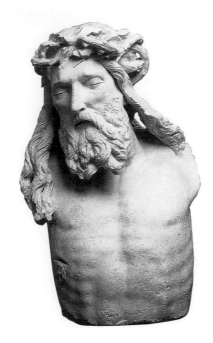

the Fearless, which was installed behind his father's in 1470 (see fig. 14). Given the relatively narrow dimensions of the church, it is not certain that Philip the Bold originally envisioned the charterhouse as a family mausoleum; perhaps he had in mind only a personal sepulcher, or thought that only he, as founder, would have his tomb placed before the altar.

We can try to interpret the way the duke is present and represented, living and dead, in the charterhouse. The new religious establishment was indeed heavily marked by the devotional practices of its founder and his family—these marks including the Virgin and the Trinity, to which the charterhouse is dedicated, and the images of Saints John the Baptist and Catherine presenting the duke and duchess on the church portal (see fig. 9). While the figure of the Virgin is universally revered, she is also, more specifically, the protectress of the French Crown. The Trinity is an object of devotion associated with the royal family of Valois, as is John the Baptist because of the parallel drawn between the baptism of Christ and the coronation of the French kings. As someone who had retired to the desert,

FIG 13 Claus Sluter (c. 1360–1406), Bust of Christ, reportedly from the Crucifixion on the Well of Moses; stone, 24 × 15 in. (61 × 38 cm); Musée Archéologique, Dijon.

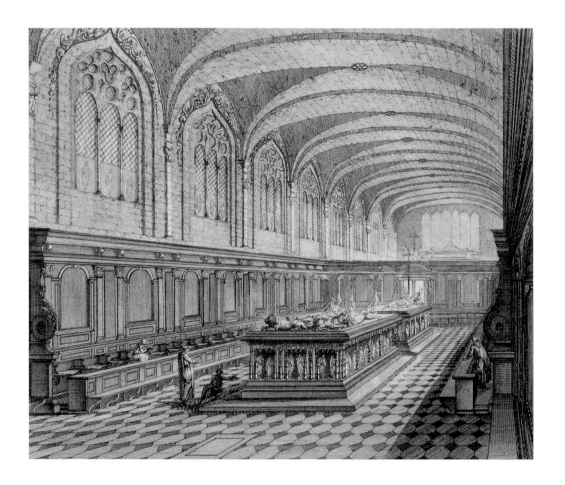

John was also particularly apt for the Carthusians. Saint Catherine was honored by both the kings of France and the counts of Flanders: Margaret's father had established a chapel in her honor in Kortrijk. Many saints are honored on the altars, including Saint Anthony, both the patron saint of the duke's birthday and a hermetic figure (see fig. 8), Saint George, the model knight (see fig. 18), and Saint Denis, patron saint of the French monarchy (see fig. 17), as well as Saints Michael, Peter, Agnes, Martin, and Hugh. The many figures of saints depicted on the altarpiece panels by Jacques de Baerze and Melchior Broederlam suggest the level of hope placed in the saints' intercession.

Moreover, many areas of the charterhouse display the coats of arms and initials of its founders, such as the portal, the painted and sculpted decorations of the church and

oratory, the altarpieces, the backs of the stalls, the stained-glass windows, the floor tiles, the walls of the parlor, the base of the Well of Moses, the gilded ornaments of the roofing, and so on. While the tomb itself does not bear any armorials, its polychromatic highlights in gold, blue, and red (see fig. 22) reprise the colors of Burgundy. No doubt, the presence of coats of arms and emblems was equally prominent in the decoration of the ducal residences and in the banquet and ceremonial halls. But here, they were meant as a perennial testimony to the prince's nobility and greatness—to his constant presence, as it were—and as an incitement for the monks (and visitors to his tomb) to pray for his eternal salvation.

The same goal is pursued in two, possibly three, further depictions of the duke. On the portal, a stone statue (see

fig. 9) portrays the sovereign prince crowned and wrapped in a grand ceremonial mantle. The prominence given the donors, who are on the same scale as the saints (albeit kneeling before them), is striking: it affirms the individual's earthly importance, of course, but also their confidence in the intercession of the Virgin and the saints. However, their "realistic" appearance is counterbalanced by the portal's complete lack of polychromy.

The visitor again finds the duke on his tomb (see fig. 29). His recumbent effigy (*gisant*), wearing armor and draped in a mantle, was sculpted in white marble, but this time heightened with polychromy that gave a more natural look to the facial features and the eyes open in resurrection, as angels watched over him. This, too, was an affirmation of the duke's belief in his resurrection, which was further aided by the prayers of the mourners parading on his tomb: their presence in the middle of the chancel must have acted as a reminder to the Carthusian monks.

Leaving the church, if one went past the first cloister—where visitors to the charterhouse were allowed, as many accounts attest—and entered the large cloister (which normally was reserved for the Carthusians), one would find oneself facing the Great Cross (see fig. 12). The detailed analysis recently published by Nash shows how the Cross synthesizes the themes at the core of Carthusian spirituality and supports the monks' devotional practices. The effectiveness of their contemplative existence and their prayers on behalf of others' salvation presupposes an intense meditation on the Passion and on penitence. If we accept Nash's identification of Jeremiah (fig. 15), the Old Testament prophet who was dearest to the Carthusians, with Philip the Bold—the likeness between them is enhanced not only by the lifelike polychromy, but also by the addition (as period accounts attest) of spectacles on the prophet's nose, much like the duke himself wore—and if we consider this depiction alongside the two others, it becomes clear that this third figure of the duke, located in the innermost recess of the cloister, on the monument that most powerfully encapsulates Carthusian spirituality, was meant to place the founder of the charterhouse at the very center of the monks' thoughts and prayers.

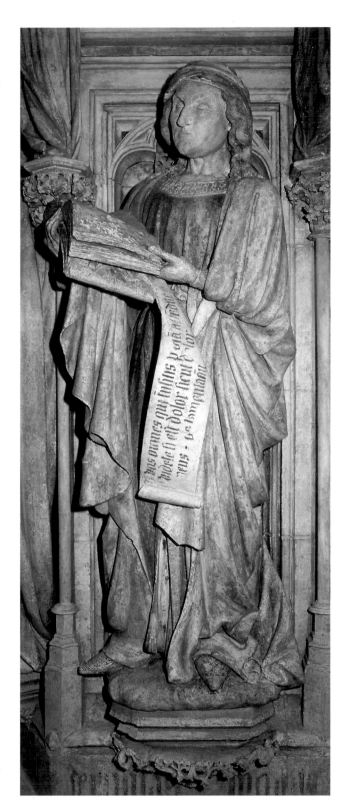

FIG 15 Claus Sluter (c. 1360–1406), the prophet Jeremiah, possibly with the features of Philip the Bold, on the Well of Moses; C.H.S de la Chartreuse, Dijon.

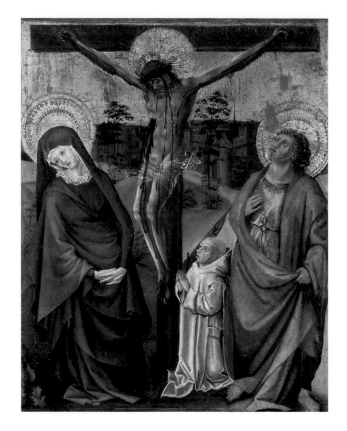

Over the course of their history, the Carthusians, in their desire for austerity and focus on meditation, have rejected precious decorations, sometimes even any imagery at all. The least we can say is that the lavishness of the Chartreuse de Champmol led them far afield from this ideal—though in fact, the same contradiction characterizes many other charterhouses, reflecting the patron's wishes, and more generally the place that icons occupied in the late Middle Ages. Still, Champmol provides an admirable example of how, despite the founder's forceful self-assertions, the monks still managed to tend to their spiritual concerns.

The Charterhouse in the Fifteenth Century

Philip the Bold's successors retained his attachment to the foundation: John the Fearless was buried there in 1419, and Philip the Good in 1474. In 1433, Philip the Good and Isabel of Portugal founded two additional Carthusian cells, including a Crucifixion painting for each (fig. 16), in gratitude for the birth of the future Charles the Bold. Three years later, Philip commissioned a portrait from the painter Jean de Maisoncelles, to be placed in the church chancel beside those of the first two dukes, confirming the timeless role of the dynasty that had established the charterhouse. The ducal portraits conserved in the chancel of Champmol would moreover serve as models until the seventeenth century.

It was under John the Fearless that certain projects reached completion, apparently not having been deemed priorities until then: for instance, one of the altarpieces for the two altars in the lay brothers' chancel was installed in 1416. According to the account ledgers, the *Altar of Saint Denis: Communion and Martyrdom of Saint Denis* (fig. 17) was completed in 1416 by Henri Bellechose, following the stylistic tradition in vogue under Philip the Bold. Judging from the style of its pendant, the *Saint George Altarpiece* or *Retable of Saint George* (fig. 18), with its more prominent masses and less refined technique, was not executed until several decades later. Tellingly, we find a Carthusian at the foot of the cross, meaning that in all probability this panel was not paid from the duke's budget but was given by one of the Carthusian fathers, who most likely contracted with a local Dijon painter rather than with the ducal workshop.

Under Philip the Good, works of art continued to embellish the charterhouse. But apart from the tomb of John the Fearless (1443–70) by Jean de la Huerta and, later, Antoine le Moiturier, these works were no longer produced by a dedicated workshop exclusively in the duke's service. Instead, the convent was adorned with paintings by the great Flemish masters and local Burgundian painters (figs. 19 and 20).

FIG 16 Anonymous, Burgundy, *The Crucifixion with a Carthusian Monk,* after 1433; oil on wood, 22½ × 18½ in. (57 × 47 cm); Musée des Beaux-Arts, Dijon.

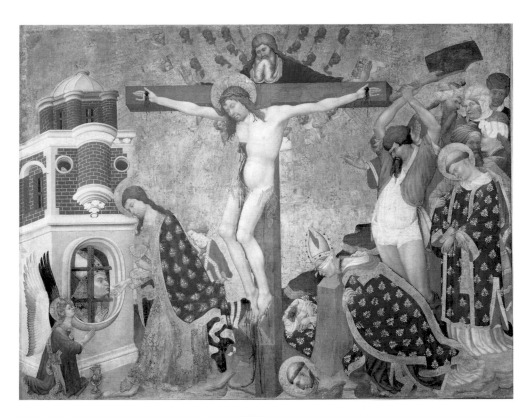

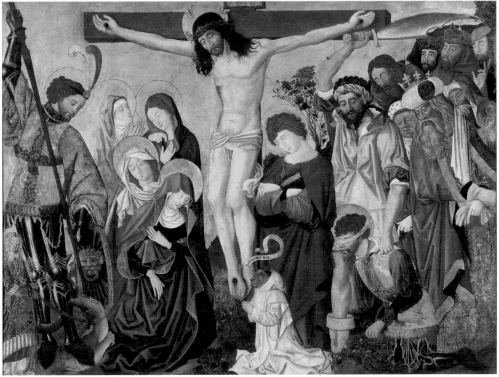

FIG 17 Henri Bellechose (fl. 1415–
before 1445), *Altar of Saint Denis:
Communion and Martyrdom of Saint
Denis,* commissioned in 1416 for the
Carthusian abbey of Champmol,
Dijon; oil, transferred from wood to
canvas, 63¾ × 83 in. (162 × 211 cm);
Mi 674; Louvre, Paris. Photo: Erich
Lessing/Art Resource, New York.

FIG 18 Anonymous, Burgundy, *Saint
George Altarpiece,* c. 1440; oil on wood,
63⅜ × 83 in. (161 × 211 cm); Musée
des Beaux-Arts, Dijon.

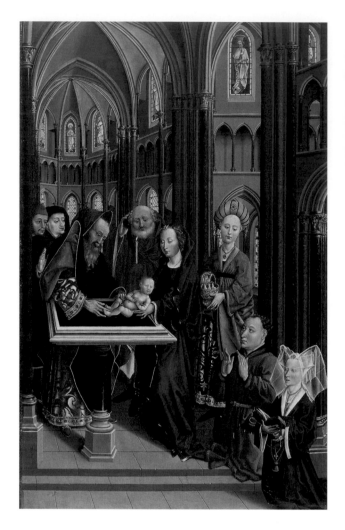

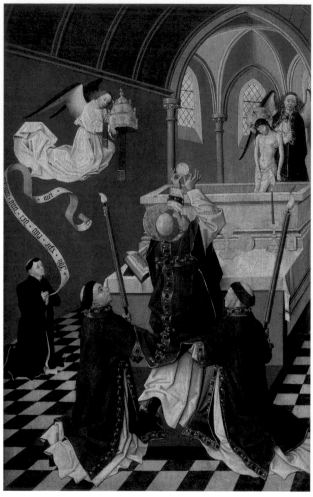

FIG 19 Anonymous, Burgundy, *The Presentation in the Temple,* mid-15th century; oil on wood, 34¾ × 20⅞ in. (88 × 53 cm); Musée des Beaux-Arts, Dijon.

FIG 20 Anonymous, Burgundy, *The Mass of Saint Gregory,* mid-15th century; oil on wood, 23⅝ × 15⅜ in. (60 × 39 cm); Louvre, Paris. Photo: Réunion des Musées Nationaux / Art Resource, New York.

The Sixteenth to Eighteenth Centuries:
The Charterhouse as Dynastic Sanctuary

Until the Revolution, the memory of the Dukes of Burgundy left a strong imprint on the charterhouse. Their heirs, the Kings of France, confirmed all the privileges of the charterhouse and nearly all of them visited, as did the French queens from the House of Austria. It was also during that period that a strange custom came into practice: after admiring the tombs, one would descend into the crypts in which the dukes' embalmed corpses were preserved and open the leaden coffins to view their faces.

For the Hapsburgs, the descendants of the Dukes of Burgundy, the dynastic value of the Chartreuse de Champmol was undiminished: in his first will in 1522, Holy Roman Emperor Charles V stated his intention to be buried in Champmol, but ultimately his remains were transferred to El Escorial near Madrid; Anne of Austria had similar intentions before she founded the Val-de-Grâce in Paris.

Eighteenth-Century Renovations

Despite some damage during the Swiss siege of 1513 and during the Wars of Religion, the charterhouse did not suffer much from violence. Rather, it was the urge for renovation that put the medieval works in peril, particularly around 1770 and until the Revolution: the church was modernized and a complete reconstruction of the buildings undertaken. The church's wooden vault disappeared under a plaster ceiling and new woodwork was installed in the chancel (see fig. 14). The small cloister was demolished and its arcades reinstalled in the marksmen's range to serve as cover. Many medieval works, poorly conserved or simply deemed old-fashioned, were replaced with paintings more in keeping with current tastes: such was the case with the Saint Denis and Saint George altarpieces (see figs. 17 and 18), which made way for works by Carle van Loo.

The French Revolution: Auction, Dispersal, Destruction

Like so many religious establishments, the charterhouse was dismantled during the Revolution and its possessions turned over to the Nation. The Carthusians definitively left the premises on April 20, 1791. On April 30, the items not kept by the Nation were auctioned off, resulting in the artworks' dispersal; many pieces can now be found scattered throughout museum collections the world over.

On May 4, 1791, the land was acquired by Emmanuel Crétet, who would become Minister of the Interior and Count of Champmol under the Empire. The new owner turned the former convent into a holiday retreat. In 1792, he demolished the church and most of the buildings, except for those he retained for his own use or to embellish his garden: the portal with its statues, the Well of Moses, the turret of the oratory chapel, and various other structures.

In May–June 1792, the tombs (and the dukes' coffins) were transported to Cathedral of Saint-Bénigne, along with the altarpieces and several woodworks. By 1793, the revolutionaries had grown more radical and aimed to obliterate every trace of the Ancien Régime; the tombs were disassembled and partly destroyed. Some of the more contemporary paintings were selected for the Dijon Museum, which opened to the public in 1799.

The Nineteenth, Twentieth, and Twenty-First Centuries: Preservation and Appreciation of the Remnants of Champmol

In 1819, the architect Claude Saint-Père undertook the restoration of the tombs, which had been placed in the Salle des Gardes of the Dijon museum in 1827 (see p. 123). The museum's curator, Charles-Balthazar Févret de Saint-Mémin, also had the *Altarpiece of the Crucifixion* and the *Altarpiece of Saints and Martyrs* (see figs. 7 and 8) restored and put on display.

In 1833, following Févret de Saint-Mémin's report to the Commission des Antiquités de la Côte d'Or, alerting the authorities to the importance of the remnants left behind at the former charterhouse, the Côte d'Or regional government bought the grounds to be used for a mental hospital. The architect Pierre-Paul Petit designed the new hospital on the spot formerly occupied by the large cloister and a chapel on the site of the former church (fig. 21).

36

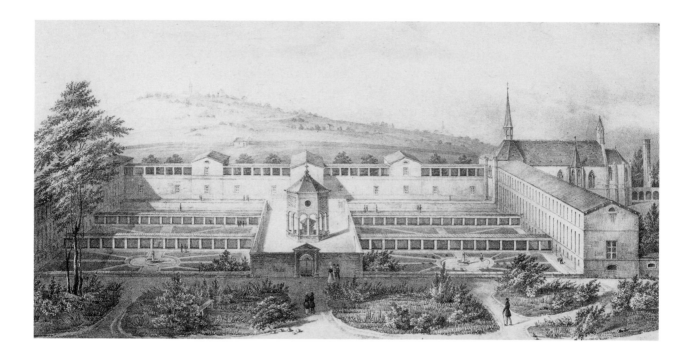

The portal and the Well of Moses were classified historic monuments in 1840, at which time the well was also restored. In 1842, excavations around the foundations of the monument revealed several vestiges of the Crucifixion, which seems to have disappeared in the eighteenth century, perhaps when the roof over it collapsed. The main discoveries were the legs of Christ and the arms of Mary Magdalene. A torso of Christ (see fig. 13), rediscovered in a niche in a house on rue Condorcet and traditionally identified as having belonged to the Christ figure from the Well of Moses, went to the Musée Archéologique in 1850. Other excavations were undertaken in 1951–52 on the site of the church and the ducal oratory, unearthing tile fragments and oratory figures. Following a second cleaning of the Well of Moses in 1946, an overhaul that lasted from 1999 to 2003 restored the well's outer portions and included a thorough cleaning of the entire monument; it revealed a polychromy that has of course faded with time, but is much more inventive than previously thought, and of extraordinary quality.[3]

The Artistic Importance of Champmol Revealed by Historians

The wealth of archival documents concerning the charterhouse, notably building invoices, has provided art historians with an unusually fertile field of research. The initial investigations by Févret de Saint-Mémin,[4] the groundbreaking publication by Cyprien Monget,[5] several contributions in the 1920s and 1930s,[6] and the exhibitions by Pierre Quarré at the Dijon museum in the 1960s and 1970s[7] have highlighted the artistic importance of Champmol. By revealing the nature and precise chronology of the construction projects, along with the names of the relevant artists, and by allowing us to better understand the conserved works and to locate throughout the world many of the works that originally came from Champmol, these studies have revealed the charterhouse, despite demolitions, dispersals, and neglect, to be a shining example of noble patronage in the late Middle Ages.

Since the 1990s, new studies[8] have significantly broadened our knowledge and deepened the analysis, widely confirming the importance and exemplary nature of the Chartreuse de Champmol.

FIG 21 Pierre-Paul Petit, *View of the Insane Asylum in Côte d'Or,* 1843; Bibliothèque Municipale, Dijon.

THE TOMBS OF PHILIP THE BOLD AND JOHN THE FEARLESS

THE TOMB OF PHILIP THE BOLD
(FIGS. 22 AND 29)

Jean de Marville (Merville [North?], ?–Dijon, 1389);
Claus Sluter (Haarlem, c. 1360–Dijon, 1406);
Claus de Werve (Haarlem, ?–Dijon, 1439); polychromy
by Jean Malouel (Nijmegen, c. 1365–Dijon, 1415);
1381–1410; black marble, white marble, partially
polychromed and gilded alabaster; 95⅝ × 100 ×
141¾ inches (243 × 254 × 360 cm)

Description

On the slab, the duke is depicted with eyes
open and hands joined, wearing his crown and a mantle
that originally covered his armor. The present effigy (the
original was destroyed during the Revolution) is an approx-
imate re-creation dating from the nineteenth century, but
we know the original through an eighteenth-century draw-
ing. The duke's helmet is carried by two angels and his feet
are resting on a lion. The ensemble is painted in natural
colors, accentuating the impression of realism.

The arcades are formed by alternating double spans
and triangular niches, sculpted with great refinement. The
white marble, originally partly gilded, contrasts with the
black of the Dinant marble of the base and slab (fig. 23).

Beneath these arcades parades the cortege of alabaster
mourners: successively, the priest bearing the aspergillum,
two choirboys, the acolyte bearing the cross, a deacon, the
bishop (fig. 24), three cantors, and two Carthusian monks
(fig. 25a). These are followed by members of the duke's
family and the officers and staff of his "house," all draped
in mourning cloaks that were, in fact, handed out at the
funeral service (fig. 25b). One final mourner brings up the
rear. The faces are individualized, but are not actual por-
traits (figs. 26 and 27).

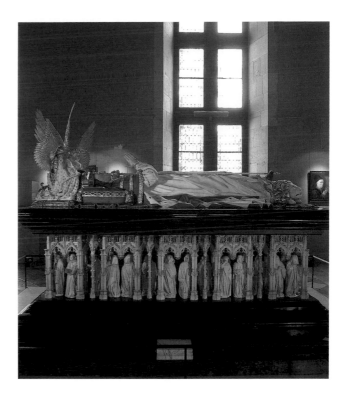

Below the slab, the tomb bore an inscription that
detailed the identity and titles of the deceased:

HERE LIES THE VERY NOBLE AND VERY POWERFUL
PRINCE AND FOUNDER OF THIS CHURCH, PHILIP
SON OF THE VERY NOBLE AND VERY EXCELLENT
AND POWERFUL PRINCE JOHN, KING OF FRANCE BY
THE GRACE OF GOD, & THE GOOD LADY, DAUGHTER
OF THE GOOD KING OF BOHEMIA, HIS COMPAN
ION, DUKE OF BURGUNDY AND LIMBURG, COUNT
OF FLANDERS, ARTOIS, AND BURGUNDY, PALATINE,
LORD OF SALINS, COUNT OF NEVERS, RETHEL, AND
CHAROLAIS AND LORD OF MECHELEN, WHO PASSED
AWAY AT HALLE IN BRABANT ON THE XXVIITH DAY
OF APRIL, YEAR OF OUR LORD ONE THOUSAND FOUR
HUNDRED AND FOUR, KINDLY PRAY GOD DEVOUTLY
FOR HIS SOUL.[9]

FIG 22 Jean de Marville (?–1389),
Claus Sluter (c. 1360–1406), Claus
de Werve (?–1439), and their studio,
Tomb of Philip the Bold, 1381–1410;
marble, polychromed and gilded
alabaster, 95⅝ × 100 × 141¾ in.
(243 × 254 × 360 cm); Musée des
Beaux-Arts, Dijon.

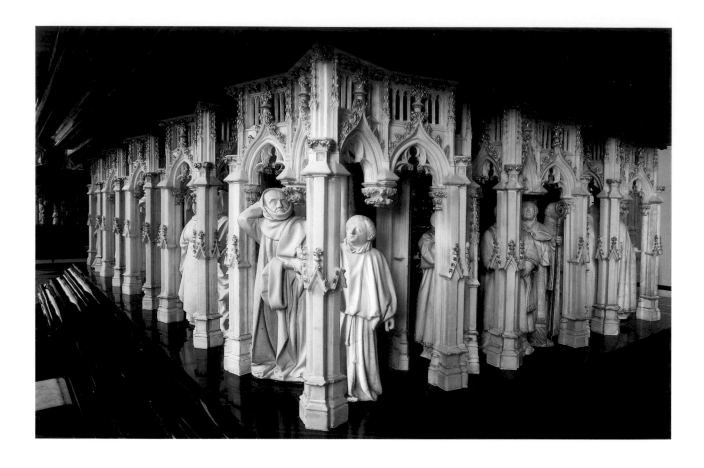

The Stages of Its Creation

Our knowledge of the genesis of Philip the Bold's tomb rests on the account ledgers for the Chartreuse de Champmol. In 1381, Jean de Marville, sculptor (*imagier*) to the duke, was assigned to "make an alabaster sepulcher for him in Dijon."[10] The work began in 1384, with workmen cutting and carving the alabaster of the arcades. In 1385, Marville bought one large and several small blocks of black Dinant marble. In October 1837, the duke visited the worksite "in the hotel of the abovementioned Marville." In December, Marville built a wooden scaffolding on which he installed the "pieces in alabaster stone . . . in the manner and to the scale of said sculpture," which seems to indicate that the arcades were well advanced by then. In 1388, two polishers came from Paris to finish the alabaster.

The polishing work continued after 1389 under the direction of Claus Sluter. In 1390, Philippot van Eram was paid for "hanging capitals," which must refer to the rosettes decorating the canopies: these are complementary elements of the architectural décor that quite logically were executed at the end of the process. In 1391, Sluter bought alabaster from Perrin Beauneveu, with which to make the mourners and cherubs decorating the canopies; this alabaster is qualified as "grenoble," which suggests that it was from Vizille, near Grenoble. In 1392, Sluter received from Christophe de la Mer, a Genoese dealer living in Paris, an "alabaster stone . . . to make an image for his sepulcher." In 1397, the prepared elements were brought to Champmol, and the masonry work on the tomb began. Sluter bought more black Dinant marble in 1397: its polishing took several

FIG 23 Tomb of Philip the Bold, detail of the arcades; Musée des Beaux-Arts, Dijon.

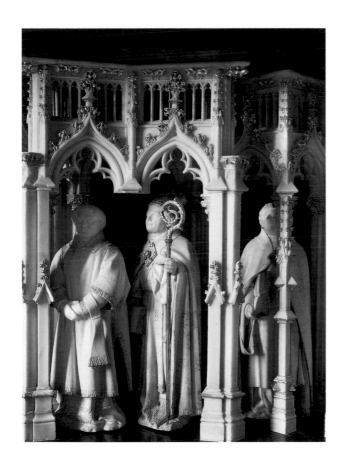

tomb was set in place in 1410, after being decorated with polychromy and gilding by Jean Malouel. The nineteenth-century restoration perfectly captured the spirit of the fifteenth-century original, which used partial highlights to underscore the luxuriousness of the materials. The flesh of the duke and the angels is naturalistically pigmented, their garments heightened in gold and color. The angels have golden hair, like the lion's mane. The small finials on the canopies are heightened in gold, which introduces a shimmering effect that was probably accentuated by the presence of the cherubs, though these had disappeared even before the Revolution. The mourners, on the other hand, were given only discreet highlights in gold or color. Only the first six mourners in the procession, in other words the members of the clergy and their assistants, were given vestments richly decorated with a stylized floral motif and lined in deep blue. For the rest of the cortege, the heightening seems to have been limited to select attributes, such as rosaries, purses, and belts in red, brown, and gold; and to platforms which, when they were visible, were green.

An Innovative Work

The iconography of a recumbent effigy with a procession of mourners is not new to Champmol, but rather reprises a tradition in use since the mid-thirteenth century, numerous examples of which can be found in monuments to the French kings in the basilica of Saint-Denis. The innovation here is at the base, the space accorded the mourners, who are not isolated and in semi-relief in their arcades, but instead seem to slip in and out of the cloister arcades. Each one expresses grief through facial expression, a gesture toward a neighbor, or the eloquence of the draperies. There is also the importance given the angels, who kneel directly on the slab and watch solicitously over the duke's deathbed, at once grief-stricken

more months. In 1402, they had to open a breach in the chancel wall to let through the large slab of black marble meant to support the recumbent effigy.

In 1404, when the duke passed away, the tomb still was not finished: the arcades were completed, but of the statuary, only two mourners were ready. In July 1404, John the Fearless directed Sluter to finish the tomb in four years: they still needed to create the recumbent figure, the two angels, the duke's helmet, and the lion, plus finish the mourners and the cherubs for the canopies. Sluter died in early 1406, apparently without having made much headway, as Claus de Werve, his nephew and collaborator, took over the contract under the same terms. It was therefore Claus de Werve who realized the figure of the duke, the lion, the two angels, and nearly all the mourners. The

 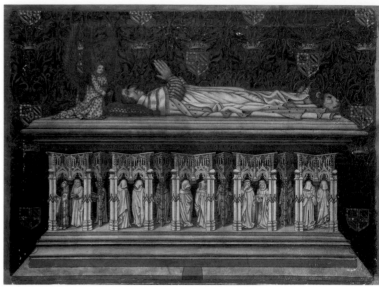

and serene (fig. 28). This composition marks a radical departure from the tomb of King Charles V, for instance, on which the king and queen's bodies were surmounted by canopies and surrounded by small niches filled with diminutive angels. Here, in contrast, the deceased appears not as a vertical statue laid flat in an architectural setting but truly like a prone body, the impression further accentuated by the folds of the mantle spread about him. And just as unusual are the monumentality of the tomb, which puts the prince's effigy nearly beyond our visual range; the preciousness of the marble and alabaster; the refinement of the polychromy; and the shimmering effect of the gilding.

Who Designed the Tomb?

Monographs on Claus Sluter always list the tomb as one of his creations. Period sources nonetheless designate Jean de Marville as the first person in charge of the project.[11] The fact that most of the arcades were completed by the time Sluter took over the worksite suggests that the placement of the mourner figures was already planned by then. Now, since all other works by Marville have since disappeared, we can only speculate about his artistic approach; but judging from the initial plan he submitted for the church portal, we have reason to believe he worked in the style in vogue under King Charles V. The formula adopted for the present tomb, on the other hand, does indeed seem innovative (at least in the absence of essential clues about its genesis, owing to the disappearance or mutilation of earlier tombs). Moreover, the three-dimensional effects and the expressiveness of the parading mourners correspond more specifically to Sluter's work.

It has therefore been suggested that the need to pierce the wall of the church chancel to let through the large slab of black marble, in 1402, indicates that Sluter had modified and amplified Marville's original plan for the tomb, as he did for the portal. The purchase of a (new?) larger slab might signify changing to a three-dimensional approach for the procession of mourners, rather than bas-relief. At the same time, barring a significant gap in the accounts, there is no indication that previously completed elements were redone, as was the case with the portal. On the contrary, the continuation of work and deliveries of materials under Sluter's direction (beginning in July 1389) indicate that the work progressed slowly but steadily, with no major evidence of a shift in direction.

FIG 25A Joannes Lesage, *Tomb of Philip the Bold, side I* (detail), second half of the 18th century; brown ink and wash, watercolor, 16¾ × 22⅞ in. (42.5 × 58 cm); Musée des Beaux-Arts, Dijon.

FIG 25B Joannes Lesage, *Tomb of Philip the Bold, side II*, second half of the 18th century; brown ink and wash, watercolor, 16¾ × 22⅞ in. (42.5 × 58 cm); Musée des Beaux-Arts, Dijon.

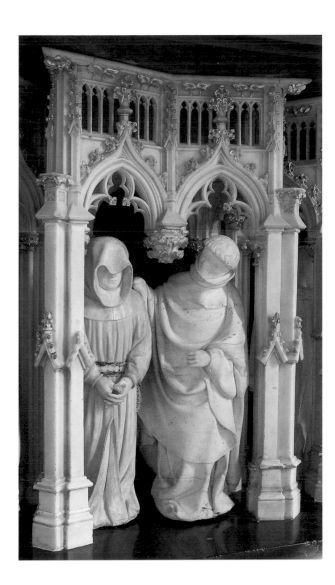

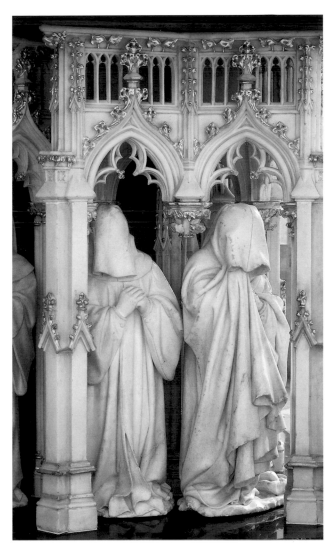

FIG 26 Tomb of Philip the Bold,
mourners nos. 20 and 21; Musée
des Beaux-Arts, Dijon.

FIG 27 Tomb of Philip the Bold,
mourners nos. 24 and 25; Musée
des Beaux-Arts, Dijon.

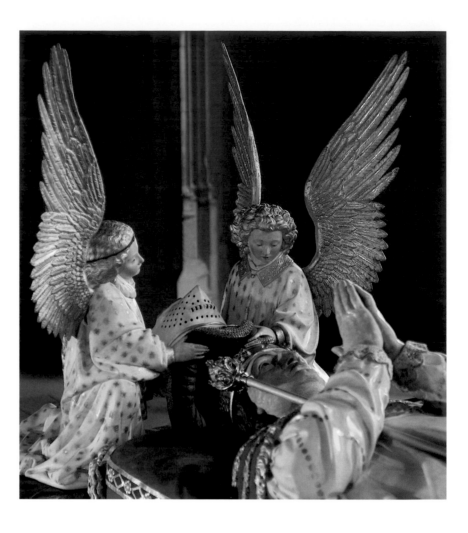

For all that, we have no way of knowing how work was organized in the studio, and whether those working under the studio head were simple executants or if the process of designing the pieces was more collaborative. Following the latter hypothesis, we might suppose that Sluter, who had worked in the studio since 1385, had already played a key role in designing the tomb. Conversely, while he didn't see the statuary through to completion, Sluter probably had a strong influence on it, as Claus de Werve no doubt had Sluter's detailed plans in hand. The recent restoration has brought to light the extraordinary interior of Philip the Bold's helmet, in which the red leather lining is rendered with incredible precision, down to the thickness of the quilted padding and the stitching holding it in place even in the deepest recess of the helmet, which is nonetheless completely invisible when set in position. Though the helmet was executed under Claus de Werve, the extreme concern with exactitude served by a mind-boggling virtuosity clearly owes much to Claus Sluter. De Werve's own style, less rigid, more supple and tender, shines through in the two angels, which dazzle by their grace.

FIG 28 Tomb of Philip the Bold, recumbent figure and angels.

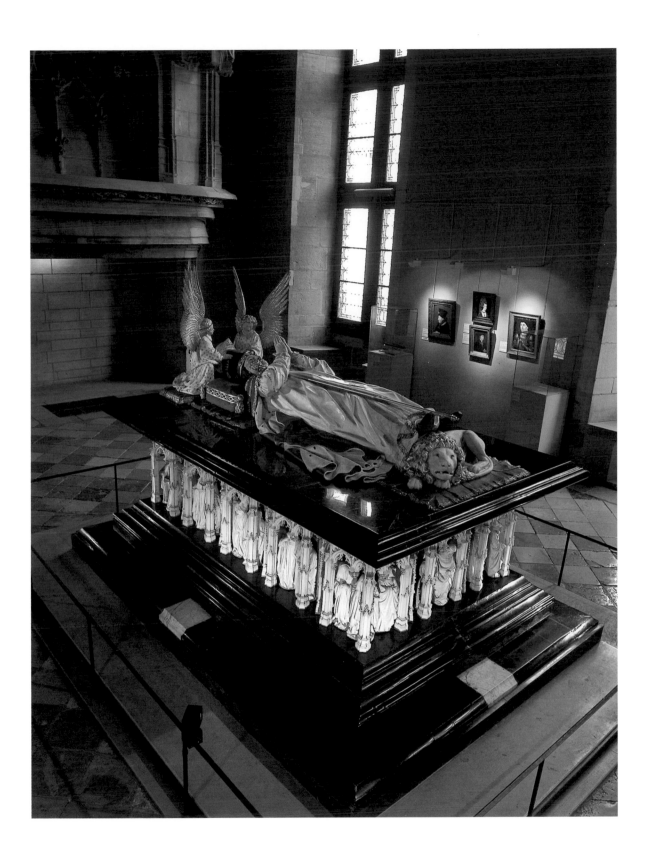

FIG 29 Tomb of Philip the Bold;
Musée des Beaux-Arts, Dijon.

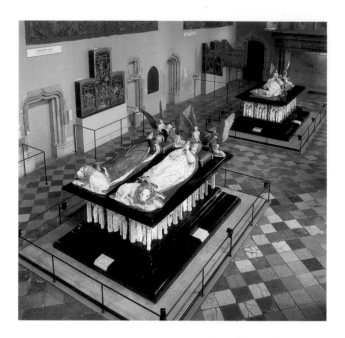

THE TOMB OF JOHN THE FEARLESS AND MARGARET OF BAVARIA (FIG. 30)

Jean de la Huerta (Daroca, ?–after 1462);
Antoine le Moiturier (Avignon, c. 1425–Dijon, 1494);
1443–70; black marble, black-painted stone,
partially polychromed and gilded alabaster;
96⅞ × 148 × 142½ inches (246 × 376 × 362 cm)

Description

The tomb of John the Fearless faithfully reproduces the look of his father's: the composition, materials, contrast of white and black marble, and highlights in gold, blue, and red are practically identical. The architecture of the arcades is more flamboyant, in keeping with the florid late-Gothic style in vogue, but the design of the mourners and funeral procession is the same (figs. 30 and 31). The one notable difference is the presence at John's side of his wife, Margaret of Bavaria: for her, the two angels carry a shield bearing her coat of arms (see fig. 32).

The Stages of Its Creation

No sooner was his father's tomb installed in the church of Champmol in 1410 than John the Fearless declared his wish to build "a sepulcher similar to the one of my late father" for himself. But nothing really got underway, not even after John's death in 1419. In 1435, his son Philip the Good renewed the commission, adding to it a plan for his own sepulcher. However, Claus de Werve died in 1439, having failed to locate suitable alabaster.

Finally, on March 23, 1443, Philip the Good made a contract with Jean de la Huerta for the tomb of John the Fearless, which was to be "as good as or better than," and of the same dimensions as, that of Philip the Bold. La Huerta was provided with a preparatory sketch for the recumbent figures by Claus de Werve. Plans for a tomb of Philip the Good, on the other hand, were no longer mentioned.

After several mishaps in rendering the figures of the two deceased, Jean de la Huerta left Dijon in 1456. The tomb components were brought to Champmol in 1457, which tells us that the gallery, mourners, angels for the slab, armor, and helmet were already made.

FIG 30 Jean de la Huerta (?–after 1462), Antoine le Moiturier (c. 1425–1494), and their studio, **Tomb of John the Fearless and Margaret of Bavaria,** 1443–70; marble, black-painted stone, polychromed and gilded alabaster, 96⅞ × 148 × 142½ in. (246 × 376 × 362 cm); Musée des Beaux-Arts, Dijon.

FIG 31 Tomb of John the Fearless, detail of the arcades; Musée des Beaux-Arts, Dijon.

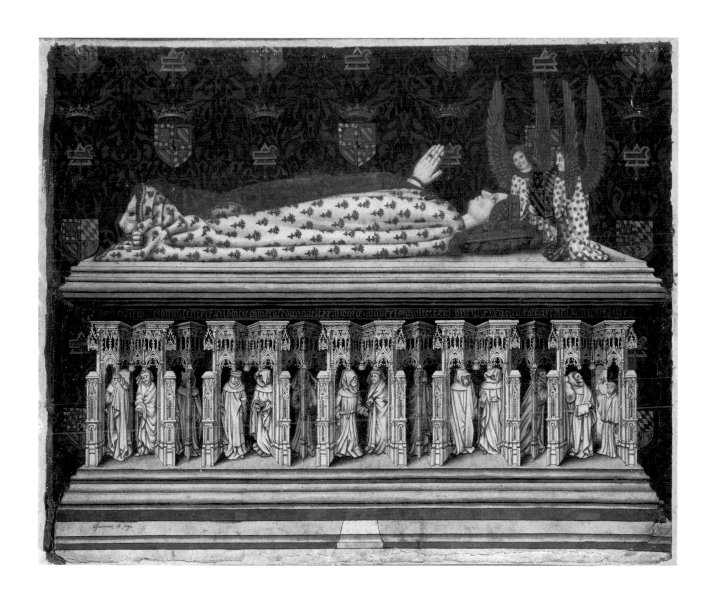

FIG 32 Lesage Muet, *Tomb of John the Fearless, side IV*, 1750; brown ink and wash, watercolor, 16½ × 21⅝ in. (42 × 55 cm); Musée des Beaux-Arts, Dijon.

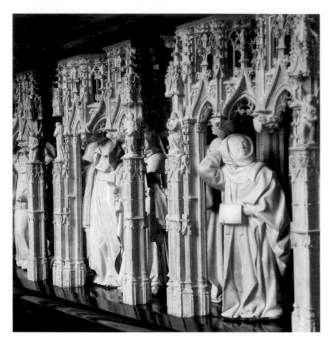

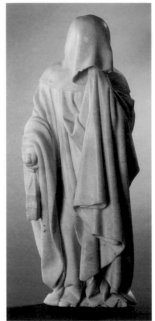

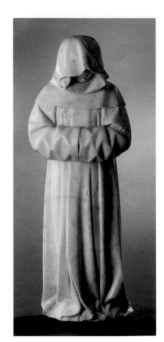

In 1461, on the advice of his sister Agnes, Philip the Good entrusted the worksite to Antoine le Moiturier, the nephew of Jacques Morel, who had executed a tomb for Charles of Bourbon and Agnes of Burgundy in Souvigny in 1446–52. Le Moiturier created the recumbent figures (1466–69) and completed the mourners and arcades. In 1470, the tomb was set in place in the chancel of the church of Champmol, behind the tomb of Philip the Bold.

A Replica of the First Tomb

Following the express wishes of John the Fearless and Philip the Good, the tomb of John the Fearless faithfully conforms to the model established by the tomb of Philip the Bold. Bound by this requirement, Jean de la Huerta and Antoine le Moiturier were hardly in a position to create an original work.

It is in the arcades, the design of which is due to Jean de la Huerta, that the tomb of John the Fearless differs the most from that of Philip the Bold (fig. 33). The decoration is clearly more complex and flamboyant. Along the upper portion runs a band on which the duke's emblems, the plane and the hop leaf, are carved. These arcades appear never to have been gilded.

As period sources suggest, it was probably la Huerta who realized most of the mourners for this tomb, since the contract with le Moiturier of 1461 directs him to "finish, polish, and complete the mourners." Pierre Quarré, in his exhibitions on Jean de la Huerta and Antoine le Moiturier,[12] suggests a division that attributes to la Huerta "the ones that display more dynamic postures or drapery with moving folds" (fig. 34), and to Le Moiturier the figures "in calm postures, with sober draperies and faces with luminous contours" (fig. 35). It is true that certain mourners, with their ample draperies, undeniably follow the tradition of Sluter, whereas others evidence a simpler design. But we must not forget that, per Philip the Good's directives, neither sculptor really departed from the model of Philip the Bold's tomb: certain mourners are direct copies (figs. 36

FIG 33 Tomb of John the Fearless, detail of the arcades.

FIG 34 Tomb of John the Fearless, mourner no. 51, attributed to Jean de la Huerta.

FIG 35 Tomb of John the Fearless, mourner no. 56, attributed to Antoine le Moiturier.

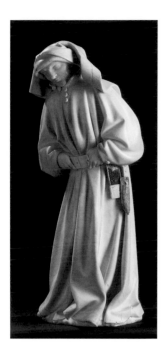
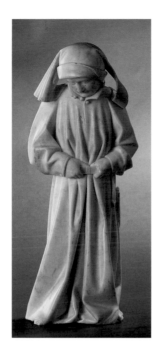

THE MOURNERS

Description

The mourners are carved in alabaster and measure between 15⅛ and 16½ inches (38.5 and 42 cm); the choirboys measure 9⅝ to 9⅞ inches (24.5 to 25 cm). Most of the mourners have never been outside of Dijon, but in the chaos following their dismantling in 1793, three of them vanished, while eight others went into private hands. Of these latter, three later returned to Dijon through national museum loans, four belong to the Cleveland Museum of Art, and one is still in a private collection.

On the tomb of Philip the Bold, choirboys 2a and 2b have been lost; mourners 17 (private collection), 18, 35, and 38 (Cleveland Museum of Art) have been replaced by casts; and no. 40 is on loan from the Cluny Museum.

On the tomb of John the Fearless, the choirboy with aspergillum (no. 41) has been lost, and mourner no. 67 (Cleveland Museum of Art) has been replaced by a cast. Number 42a was a gift of Mr. Percy Moore Turner, no. 42b (Arconati-Visconti Collection) is on loan from the Louvre, and no. 68 is on loan from the Cluny.

The Mourners in the Overall Composition of the Tombs

While the procession of mourners is the most celebrated aspect of the tombs of Philip the Bold and John the Fearless, it is by no means the only major motif: the main feature naturally remains the figures of the deceased. But the mourners form an integral part of the composition, and we cannot emphasize too strongly the coherence of the message of faith that these tombs convey. The life-size recumbent effigies, with their naturalistic faces and precisely rendered costumes, seem to belong to our world. But their eyes open in resurrection, the angels accompanying their reawakening—heavenly creatures depicted as realistically as if they were earthly figures (fig. 38)—show them as they will be at the end of time, when bodies rise in glory and all souls rejoin the Creator. To ensure that the dukes would indeed number among the Chosen on Judgment Day, the prayers of the

and 37), and those that differ nonetheless retain the same spirit.[13] As such, trying to attribute the mourners to one or the other sculptor is a delicate matter.

As on the tomb of Philip the Bold, the tomb of John the Fearless bore a long inscription:

HERE LIE THE VERY NOBLE AND VERY POWERFUL PRINCE AND PRINCESS JOHN DUKE OF BURGUNDY COUNT OF FLANDERS ARTOIS AND BURGUNDY PALA-TINE LORD OF SALINS AND MECHELEN SON OF THE LATE VERY NOBLE AND VERY POWERFUL PRINCE PHILIP SON OF THE KING OF FRANCE DUKE OF BUR-GUNDY FOUNDER OF THIS CHURCH AND LADY MAR-GARET OF BAVARIA HIS SPOUSE, SAID DUKE JOHN HAVING PASSED AWAY ON THE XTH DAY OF SEPTEM-BER IN THE YEAR MCCCCXIX AND SAID LADY HIS SPOUSE ON THE XXIIITH DAY OF JANUARY IN THE YEAR MCCCCXXIII KINDLY PRAY GOD DEVOUTLY FOR THEIR SOULS.[14]

FIG 36 Tomb of Philip the Bold, mourner no. 34.

FIG 37 Tomb of John the Fearless, mourner no. 73.

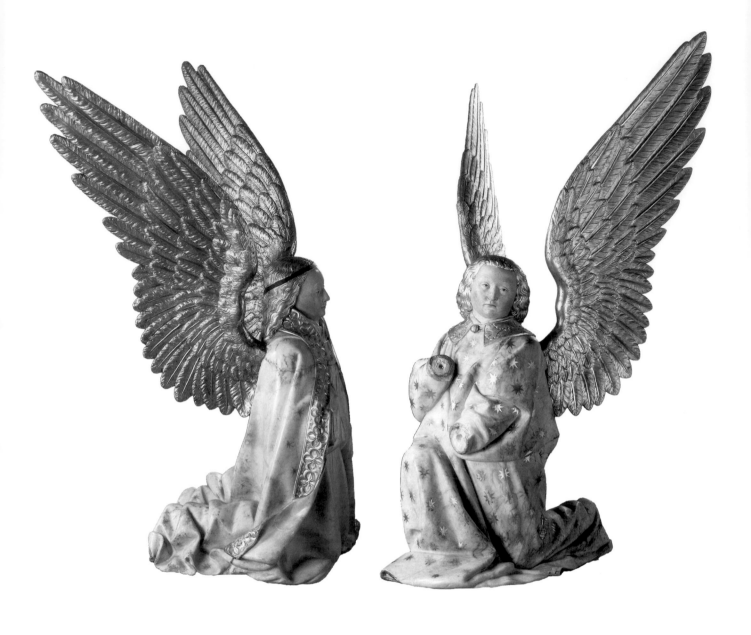

FIG 38 Tomb of John the Fearless,
details of the angels.

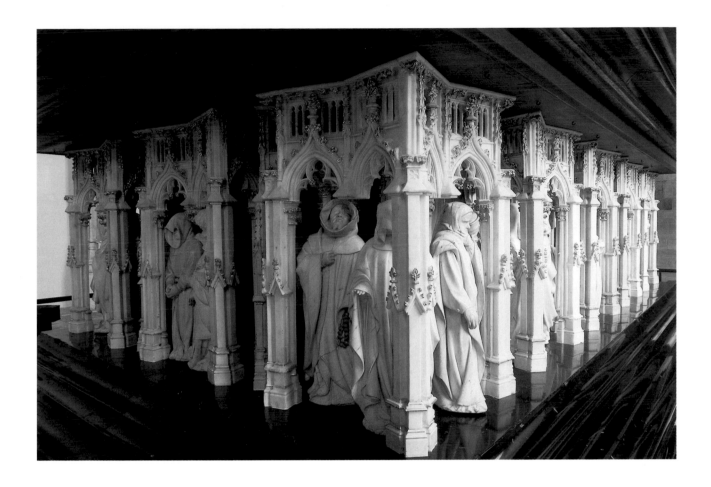

living were indispensable—hence the necessity that on their tombs, mourners, evoking the funeral procession that brought together various strata of society (secular clergy, regular clergy, and laypersons) (fig. 39), should weep and pray eternally for the deceased.

The Mourner Motif in Funerary Arts

It is important to restate here that the inclusion of mourners on the tombs of the Dukes of Burgundy is not new.[15] The mourner motif dates back to ancient sarcophagi, which often displayed rows of figures or scenes under arcades. Mourners under arcades reappear in Roman times, both on tombs and in architecture: the figures might be apostles, saints, monks, or angels, while the scenes might show episodes from the New Testament or the lives of the saints. It was around the turn of the twelfth

century that one began to see funerary monuments placed above ground inside a church, first as a way of honoring persons long dead. Monarchs and princes, who tended to build family mausoleums, began placing over their own sepulchers monuments intended to perpetuate their memory, with the practice later spreading to the nobility and high clergy.

Apparently it was in the mid-thirteenth century, in the circle of Saint Louis (Louis IX), that the idea of depicting the funeral procession in all its components and all its emotion first took root: the earliest known tombs of this type are those of Philip Dagobert, Louis IX's brother (d. 1234), and of his eldest son, Louis (d. 1260), who were buried in the Cistercian abbey of Royaumont. On Louis's sarcophagus (today in the basilica of Saint-Denis), the procession begins with the litter supporting the body of the deceased,

FIG 39 Tomb of Philip the Bold,
detail of the mourners, side I.

carried by four porters and followed by a parade of clerics and laypersons. The concept spread throughout Western Europe, particularly in the fourteenth and fifteenth centuries. In stone, marble, or (as in the case of Champmol) alabaster, we often find mourners on the sepulchers of great men, such as popes, kings, princes, cardinals, bishops, and abbots. Sometimes they depict individual members of the deceased's family, as on the tomb of Pope Clement VI (d. 1352) in the chancel of the abbey of La Chaise-Dieu, and sometimes they bear the family's coat of arms.

The Tombs of the Dukes' Relatives

When Philip the Bold commissioned his tomb in 1381, the model of tombs with recumbent effigy and mourners was by no means the only one available, but we can presume it was considered the most suitable for a great prince. Because the tombs of Philip's brother King Charles V (d. 1380) in Saint-Denis, created around 1376, and of his brother Louis of Anjou (d. 1384) in Angers have been destroyed, we cannot ascertain that they featured such figures, but we do know that the fourth son of King John the Good—John, Duke of Berry (d. 1416)—adopted this approach for his tomb in the holy chapel he had founded in Bourges.[16] After the Burgundy mourners, John of Berry's is the best-conserved grouping, with twenty-seven known figures, but it is incomplete and dispersed. Realized in two stages, the first before 1438 by Jean de Cambrai and the second in 1450–53 by Étienne Bobillet and Paul Mosselmann, these mourners are not imitations of the Champmol figures, even if they show some similarities. In the following generation, King Charles VI (d. 1422), son of Charles V, also had a sepulcher with mourners, and the Dukes of Bourbon, in Souvigny, followed that model as well.

One notable exception comes from Louis d'Orléans (d. 1407), the brother of Charles VI, who provided in his will of 1403 that he be buried in the chapel he founded in 1394 in the church of Les Célestins in Paris. Out of humility, he asked to be buried in the ground without a coffin, in the robes of a Celestine monk, and to be depicted dead, in religious attire, head and feet resting on rough-cut stone,

his body in white marble placed on a black marble slab a mere several inches from the ground with no base.

Innovative Tombs of Remarkable Quality

Among funerary monuments, the tombs of the Dukes of Burgundy nonetheless stand out in and of themselves, and not merely because they are the only princely tombs from the fourteenth and fifteenth centuries to be, if not quite intact, at least—thanks to the reassembly and restorations of the nineteenth century—in a state of completeness that allows us to study and admire them. This seems a good place to reiterate what makes them so extraordinary.

First, and most often noted, is the concept of mourners as three-dimensional figures in the space created by the arcades. The arrangement, which has the figures circulate, as it were, under the cloister galleries, resolves the issue of mourners confined in an arcade. Monotony is avoided by the variety of the figures themselves, and by the alternation of simple triangular canopies covering one figure, rectangular double canopies covering two figures, and, in the corners, more complex canopies covering three figures.

In addition, there is of course the lifelike and immediately affecting character of this group of clerics and laypersons, the overall elegance of the figures draped in their cloaks, the care taken in rendering every detail of clothing and accessories, which confers variety without undermining the overall effect, and the many different postures and expressions, which draw and hold the viewer's rapt attention.

So far, we have devoted less discussion to the upper part of the tombs, perhaps out of reticence over the amount of restoration: the three recumbent figures are not originals but nineteenth-century reproductions. Nonetheless, studies preparatory to the restorations of 2003–05 allow a better understanding of their innovative character.[17] The recumbent effigies, angels, and lions are alone on the stone slab, without the canopies and arcades that surrounded the figures of the deceased on earlier tombs and that reprised in three dimensions the decorative elements from below the slab. Instead, the traditional model here yields to a more

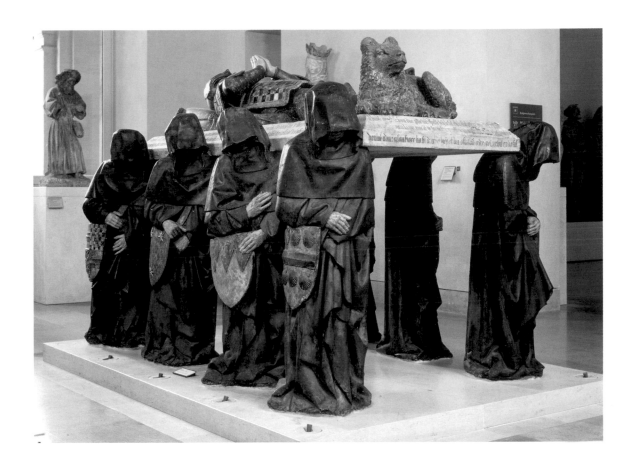

"realistic" depiction of the dukes' bodies at the moment of resurrection, with angels in attendance. The life-size scale of the recumbent figures (though the originals were smaller than the nineteenth-century replicas) and the convincing look of the bodies, costumes, and colors make for a particularly striking vision.

The desire to create a lasting impression is well served by the extraordinary quality of the sculpture. Admittedly, the level of Philip the Bold's tomb sculptures, successively overseen by Jean de Marville, Claus Sluter, and Claus de Werve, is superior to that of John the Fearless, under the chisels of Jean de la Huerta and Antoine le Moiturier; but the quality of the latter is still extremely high. Nor should we neglect the role played by polychromy in the overall effect. Some scholars have hesitated to pass judgment on polychromy that was entirely redone in the nineteenth century; but here again, the studies preparatory to the restoration fully confirm its fidelity to the original. The rightness of the proportions, ampleness of the draperies, exactitude of the details, beauty of the faces and expressions, virtuosity of the workmanship, the balance between components and overall effect, and the wide-ranging mastery required to bring something as complex as a monumental tomb to fruition never fail to leave us awestruck.

A final word should be said about one especially praiseworthy feature of the mourners: the draperies, which are majestic, often ample, sometimes very simple, and always eloquent. In the admirable sculpted output of France, it was in the quality of the draperies that Burgundy stood out, and these draperies were clearly executed by the duke's sculpture studio: Claus Sluter, Claus de Werve, Jean de la Huerta, Antoine le Moiturier, and their collaborators. As the only authentic, documented works from the dukes' studios to have survived (apart from the figures on the church

FIG 40 Anonymous, Burgundy, *Tomb of Philippe Pot, Grand Senechal of Burgundy* (d. c. September 15, 1493), 1477–83; polychrome stone sculpture group, 71¼ × 102⅜ × 65¾ in. (181 × 260 × 167 cm); Louvre, Paris, from abbey church of Cîteaux, Burgundy. RF 795. Photo: R.G. Ojeda, Réunion des Musées Nationaux/ Art Resource, New York.

portal and the Well of Moses), the mourners serve as a kind of referent for dating and attributing other Burgundian sculptures. Sometimes we can advance indisputable similarities between a given statue and a given mourner, as in the case of mourner no. 78 and the Trinity, Church of Genlis, whose postures and folds in their mantles are very close.[18] Further study is needed to determine if these similarities resulted from direct influence, shared source material, studio models, or something else altogether.

Posterity of the Mourners Theme

Outside of the French royal family and its collateral branches, the mourners theme remained in use until the beginning of the sixteenth century, though this does not necessarily reflect a direct influence of the Champmol tombs. Indeed, the exceptional quality of the latter made them virtually impossible to imitate and they were never exactly copied, not even on Burgundian family tombs outside of Champmol. At the monastery of Brou in Bourg-en-Bresse, Margaret of Austria took inspiration from Champmol for the tombs of her husband (Philibert II, Duke of Savoy) and his mother (Margaret of Bourbon), which reprise the mourners theme, but on her own tomb she opted for two superimposed depictions of her recumbent effigy, one in resurrection and the other in death.

The mourners would even undergo a relative democratization, with funerary motifs in black stone that became a specialty of Tournai in Flanders (today Belgium) in the fifteenth century: intended for less elevated social classes, they feature a repetitive series of mourners in frontal view beneath an arcade. At the Dijon museum, the tomb of Pierre de Bauffremont, which comes from the church of Notre-Dame in that same city, provides a good example of this.

At the end of the fifteenth century, the mourners theme received a final and unusual twist with the tomb of Philippe Pot (d. 1493), a lord in the court of Philip the Good, for his sepulcher at the abbey of Cîteaux. The tomb depicts the recumbent lord in armor draped in a tunic bearing his coat of arms, a lion at his feet, on a slab carried on the shoulders of eight nearly life-size mourners (52¾ to 56¾ in.; 134 to 144 cm), each wearing ample black cloaks with cowls that hide their faces, and bearing large shields corresponding to Philippe Pot's eight generations of noble lineage (fig. 40). Executed between 1477 and 1483, thus during Pot's lifetime, this one-of-a-kind tomb no doubt conforms to the client's explicit instructions. We can only imagine what his funeral services were like.

The Relation of the Mourners to Funeral Rites

The theme of mourners can, indeed, be related to the funeral rites themselves. The ceremonies surrounding the funerals of kings and princes expanded considerably in the late Middle Ages[19]: the event went on for days, even months if one had to transport the body back to its place of burial—as was the case for the first three Dukes of Burgundy, who died far from Dijon. The services involved funeral processions, several liturgical celebrations, and numerous participants, including the poor, who played an important role. The lavishness of these events was impressive indeed: black drapings, canopies, catafalques, a golden drapery over the coffin, armorials, presentation of the items of tribute (the deceased's banners, weapons, and horses), insignia of the prince's power, and candles and music in abundance. The ceremonies might conclude with a funeral banquet. And they might be repeated several times over if the deceased had commissioned, alongside a tomb for his body, a second for his heart and a third for his entrails—though this custom was not observed in Burgundy.

The rich archives of the dukes' accounts tell us about the dukes' funerals in minute detail.[20] The most interesting aspect was the distribution of hooded black cloaks to all the participating laypersons, from the members of the duke's family on down, "knights and chamberlains" to pages and grooms,[21] while the members of the secular and regular clergy wore the garments of their station. The carriages and horses were also draped in black. Even if we can well imagine that the heir to the duchy wore a more luxurious outfit than the servants, it was nonetheless the case that class distinctions, normally expressed through dress, became temporarily suspended, the black of mourning reminding all present that death was an experience shared by everyone.[22]

The tomb's mourning figures, which single out only the members of the secular clergy and the Carthusians, but treat all other participants of the funerals equally, are a faithful reflection of the sight that the dukes' services must have offered.

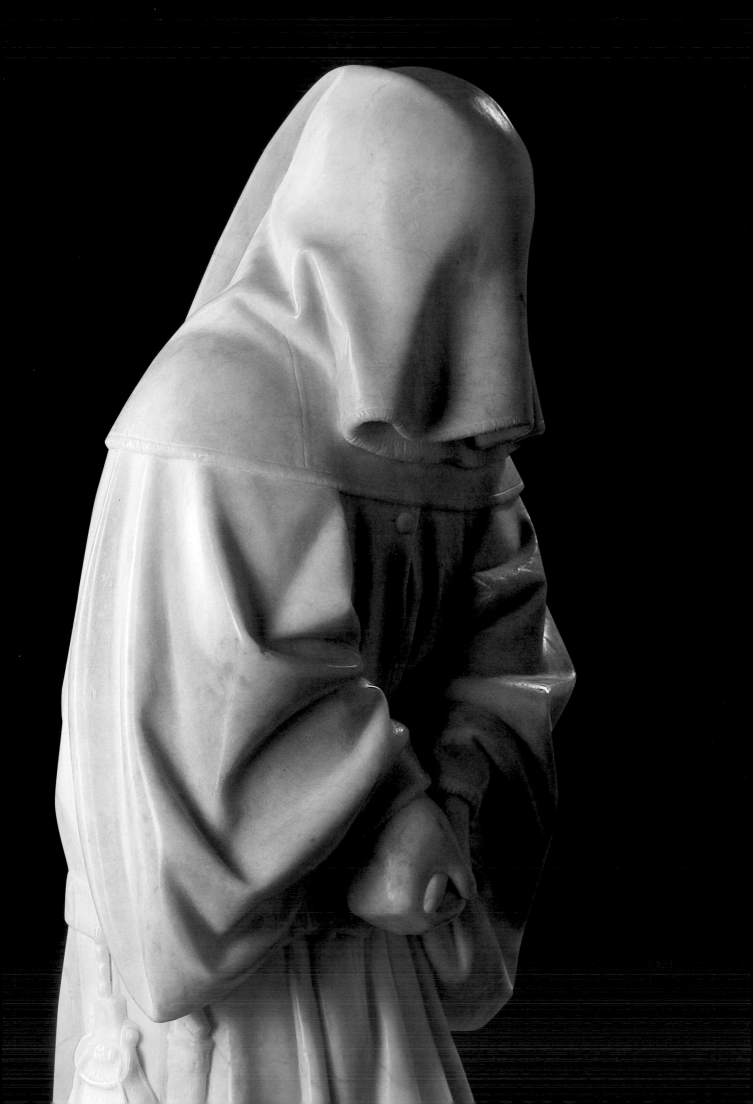

MOURNERS FROM THE TOMB OF JOHN THE FEARLESS

The mourners were numbered according to a system, now canonical,
from 1 to 40 (Philip the Bold) and 41 to 80 (John the Fearless).[23]

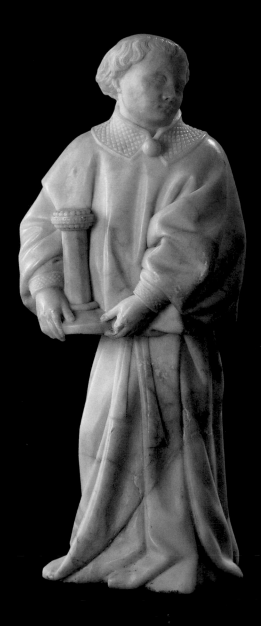
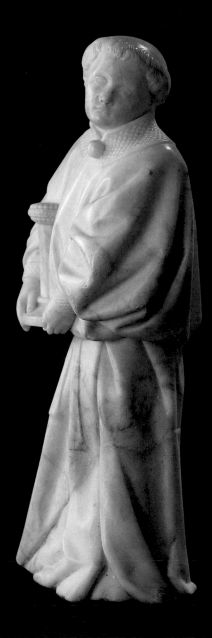

№ 42A choirboy holding a candlestick

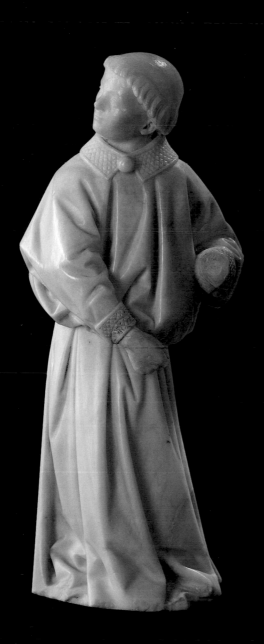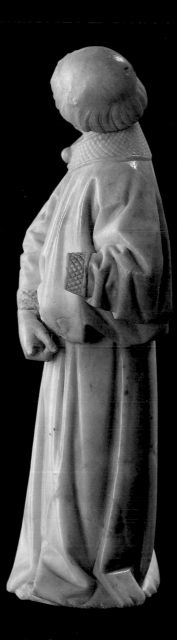

№ 42B choirboy (hands broken)

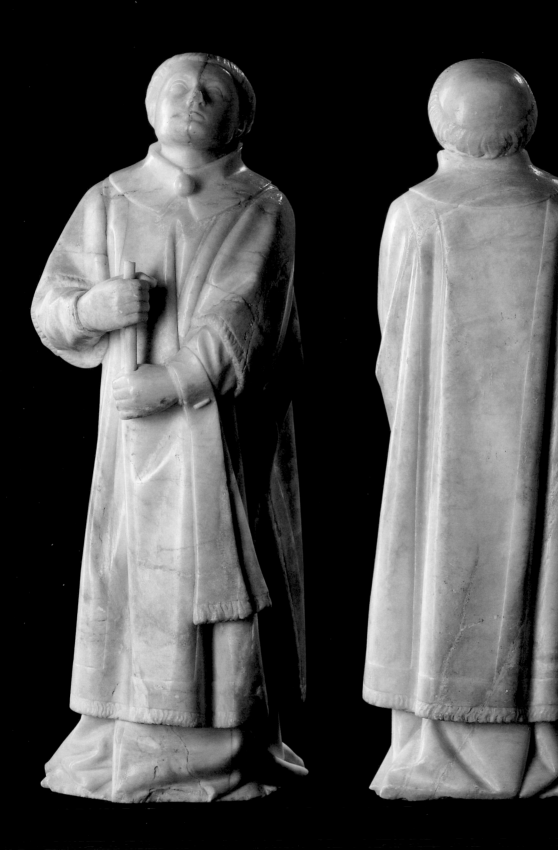

N° 43 deacon holding a cross (cross broken)

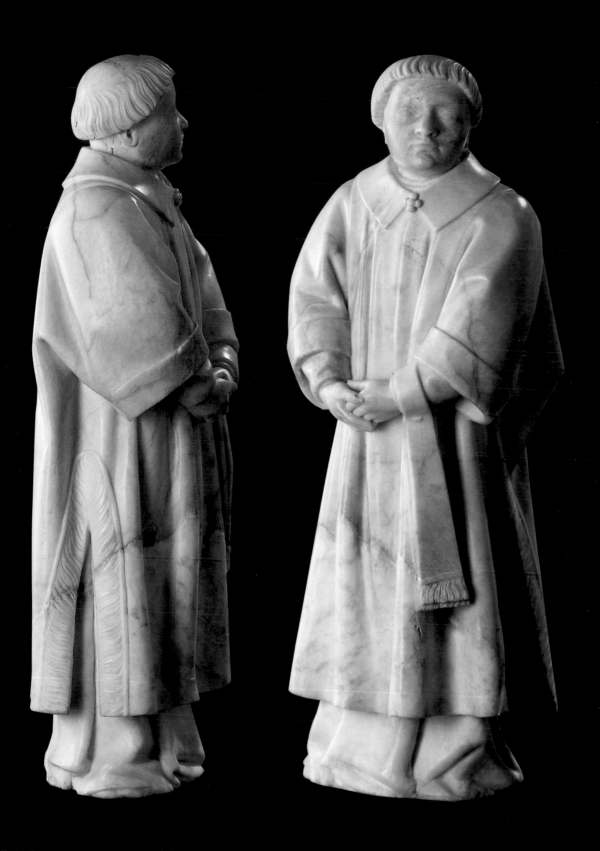

№ 44 deacon with hands joined

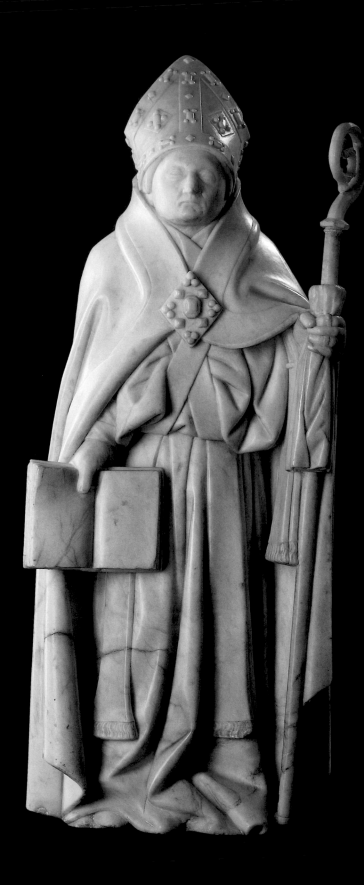

№ 45 bishop

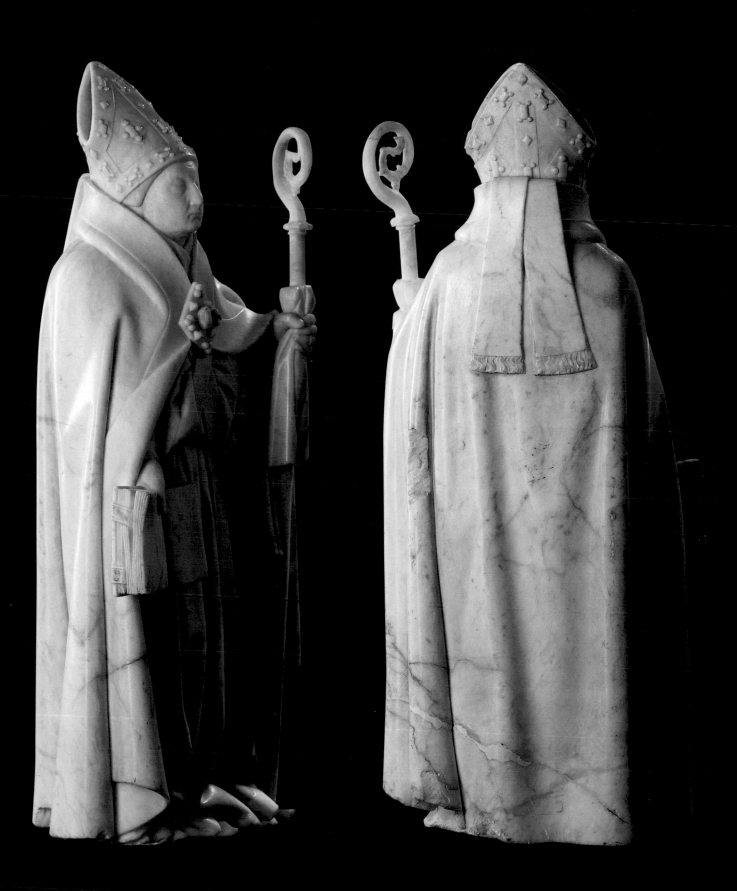

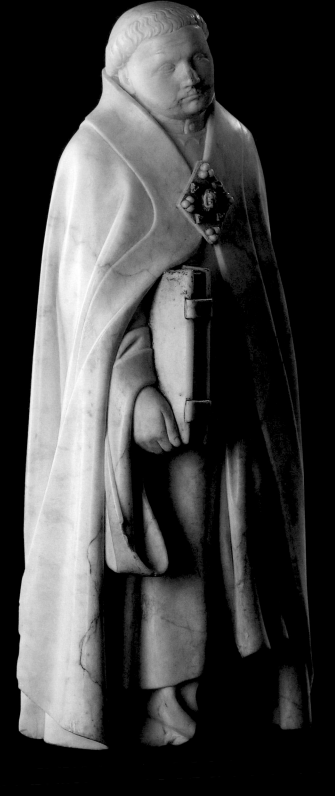

№ 46 cantor holding a closed book

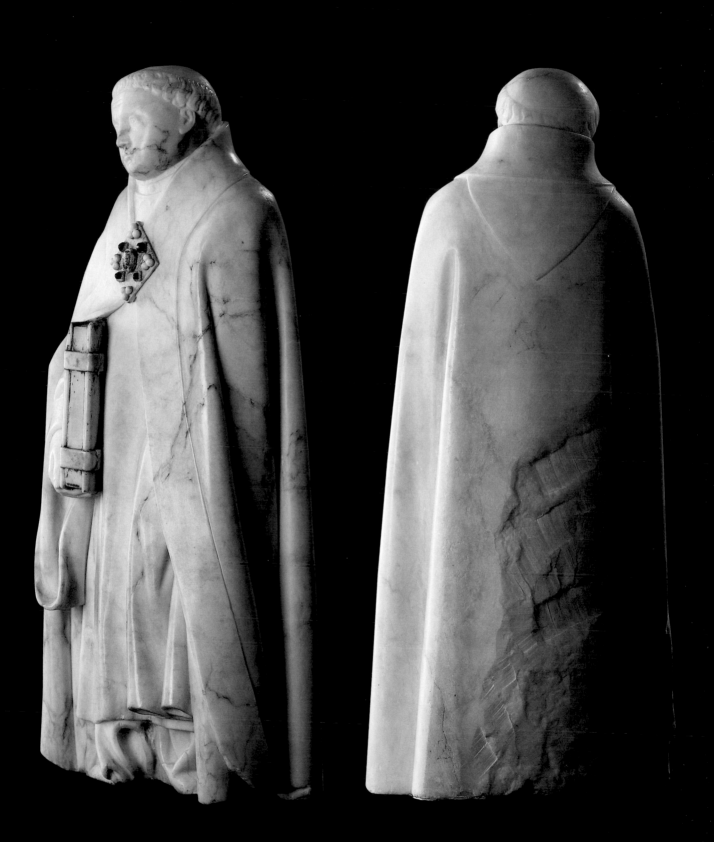

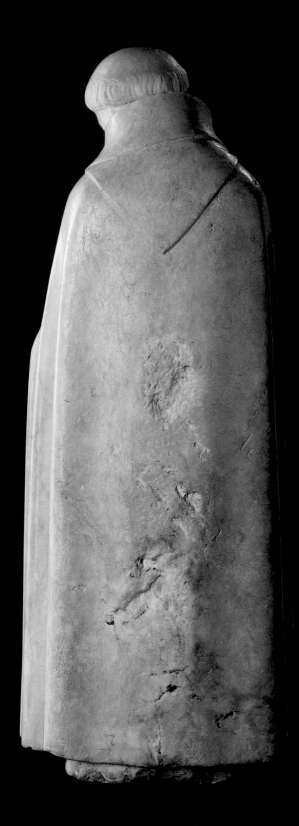
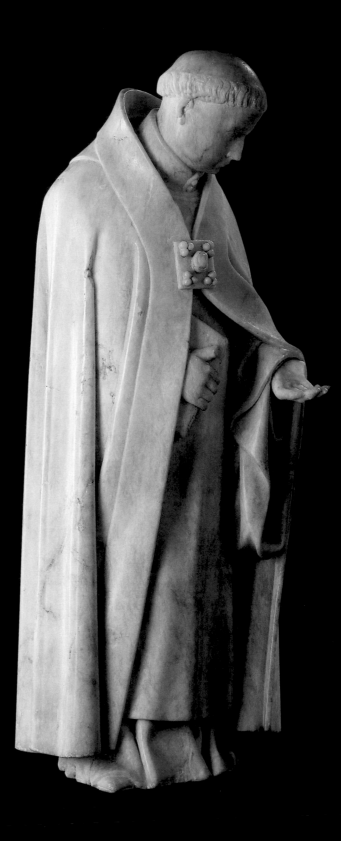

№ 47 cantor holding up his neighbor's book
(left hand broken)

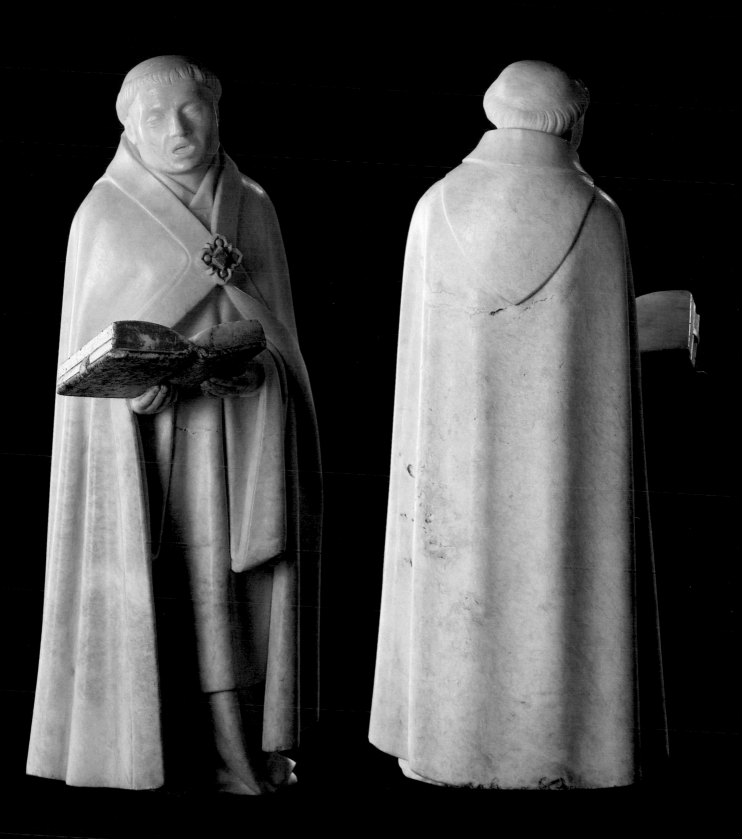

№ 48 cantor holding an open book in both hands

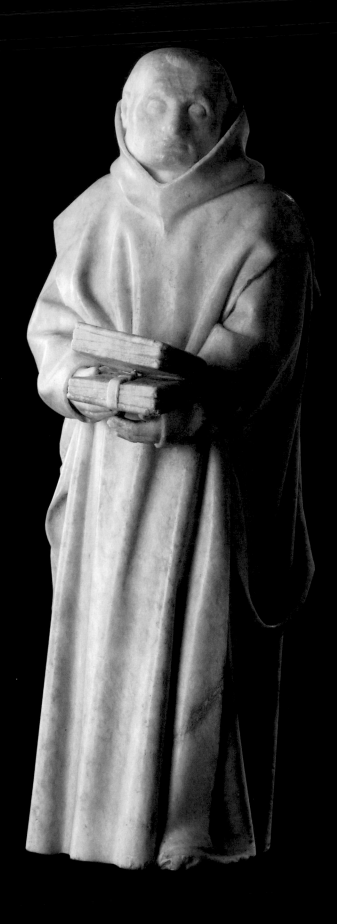

№ 49 Carthusian monk holding a book

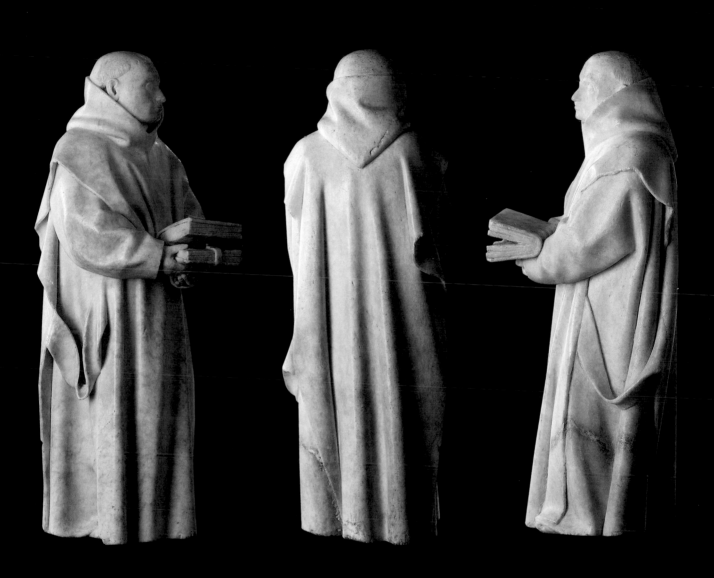

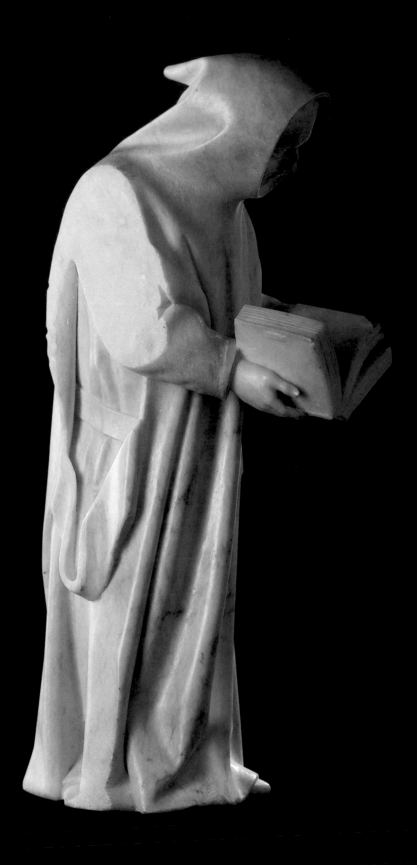

№ 50 Carthusian monk reading

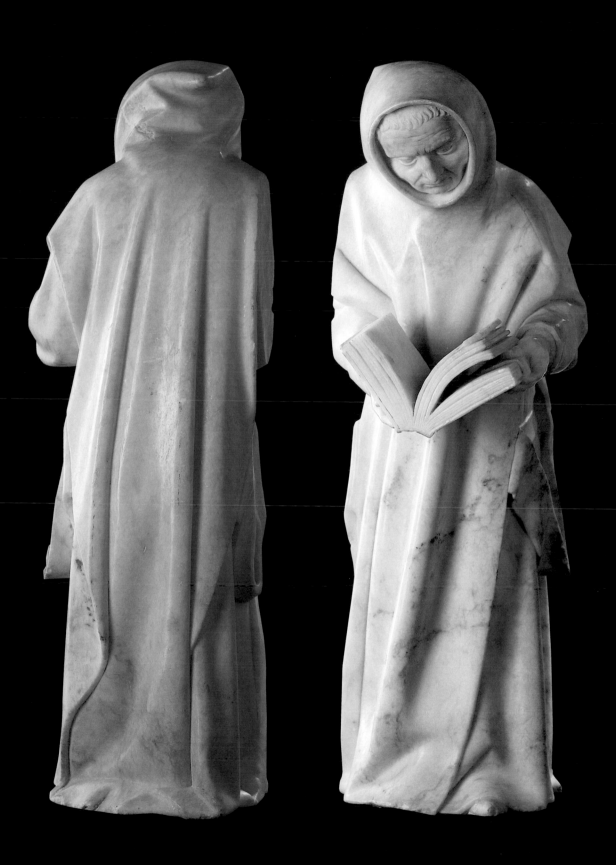

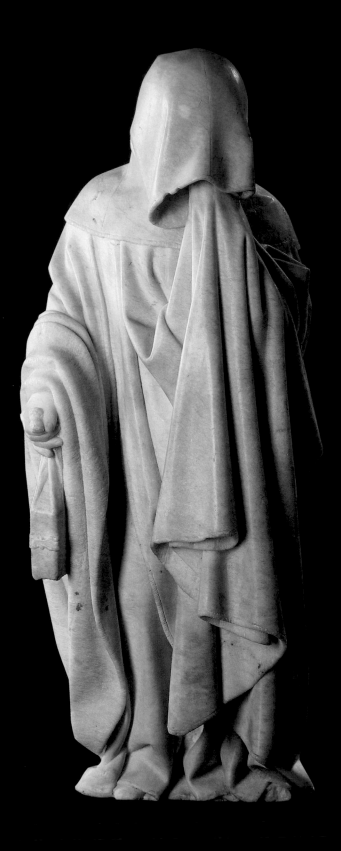

№ 51 mourner with cowl pulled down,
holding a book in his right hand and with his
left hand wiping his tears on his cloak

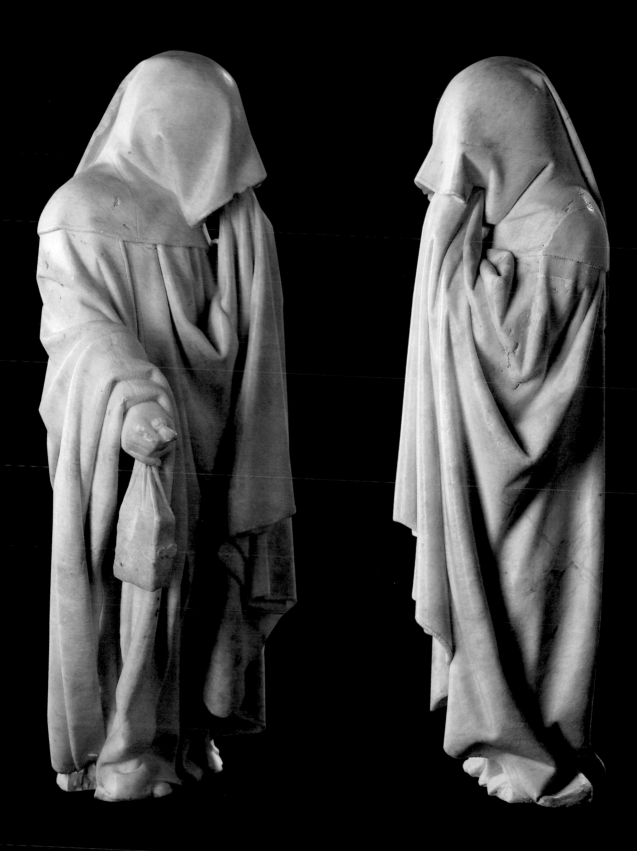

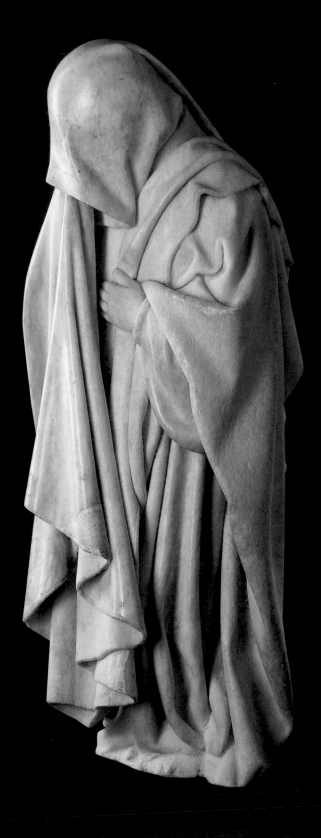

№ 52 mourner with cowl pulled down,
wiping his tears on his cloak with his
right hand, left hand on his chest

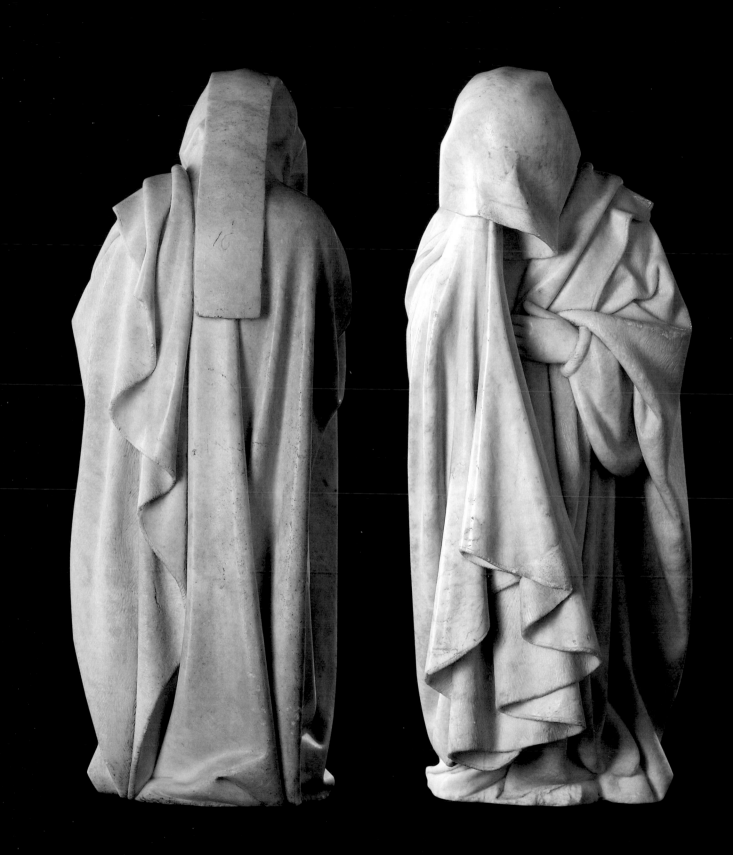

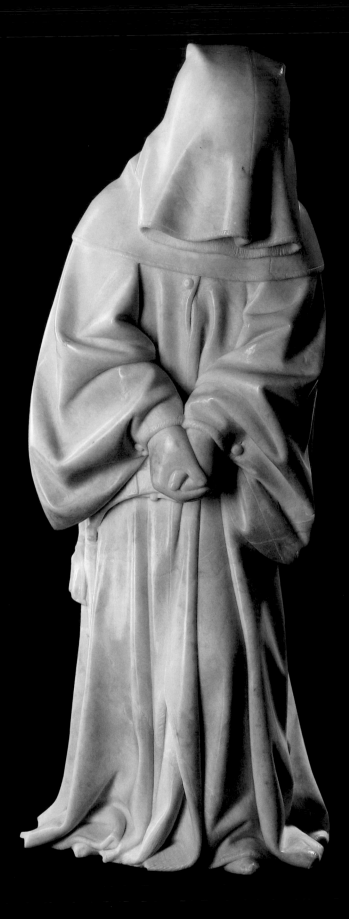

№ 53 mourner with cowl pulled down,
hands joined at waist level

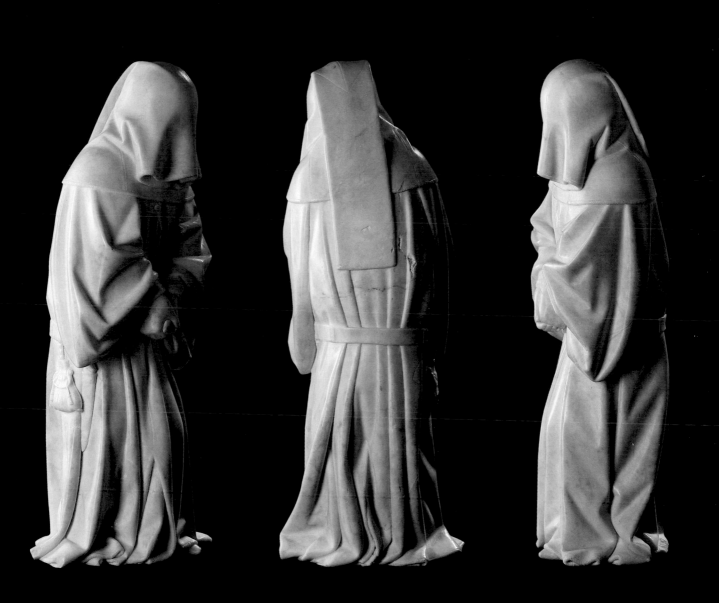

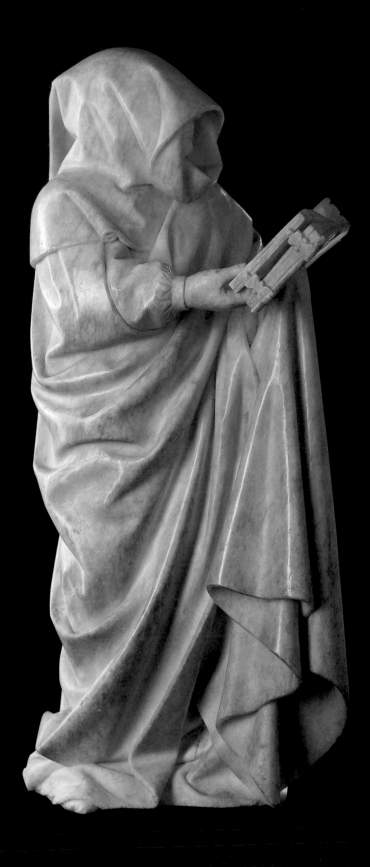

№ 54 mourner with cowl pulled down, reading a book

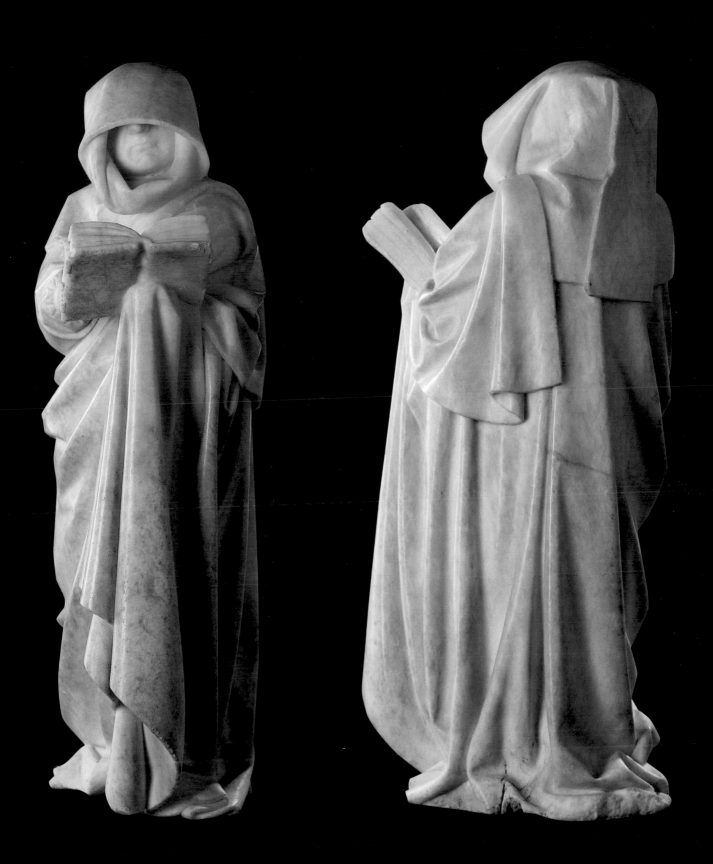

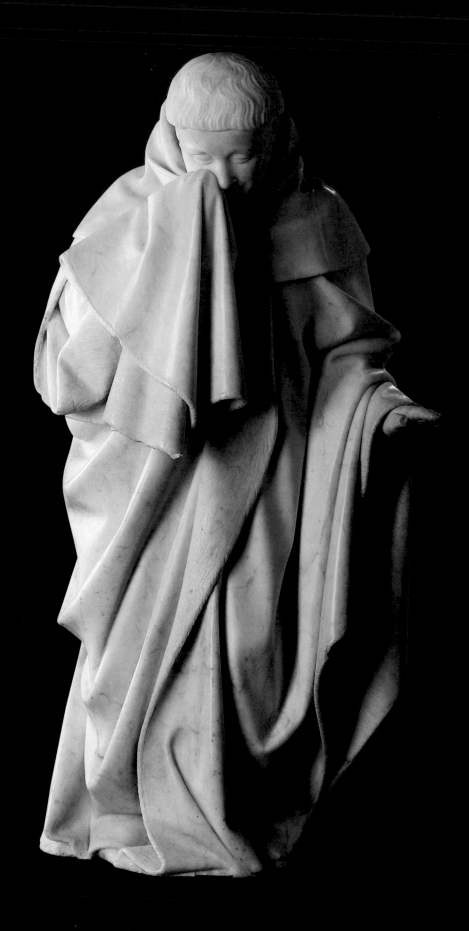

N<u>o</u> 55 mourner with head uncovered,
wiping his tears on his cloak with his right hand

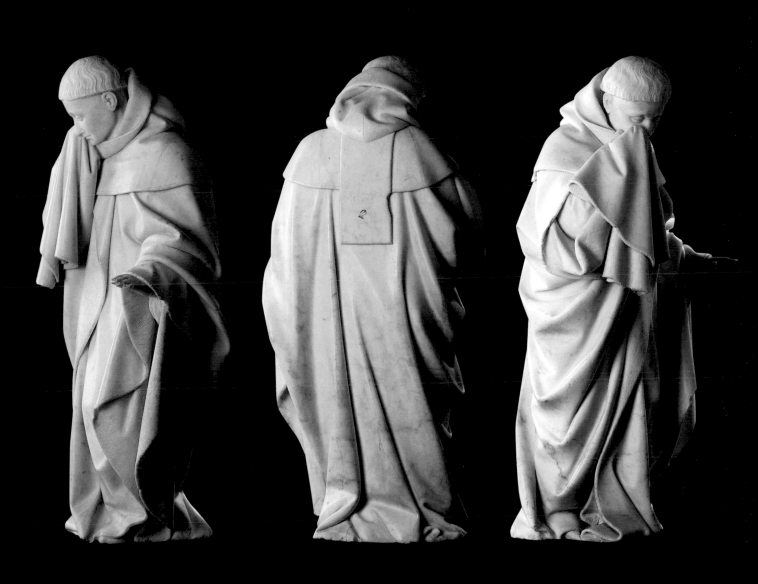

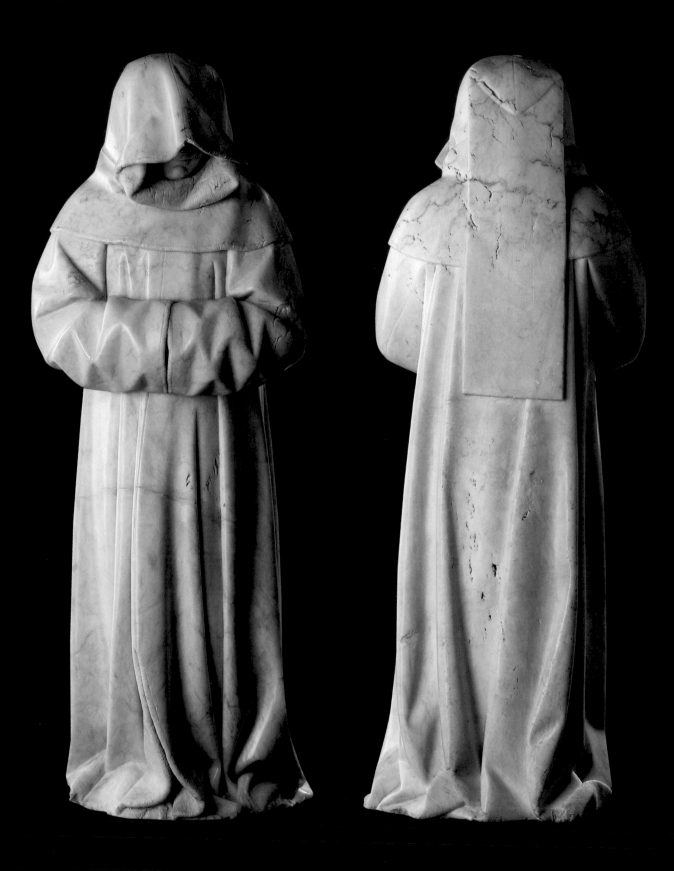

№ 56 mourner with cowl pulled down,
hands in his sleeves

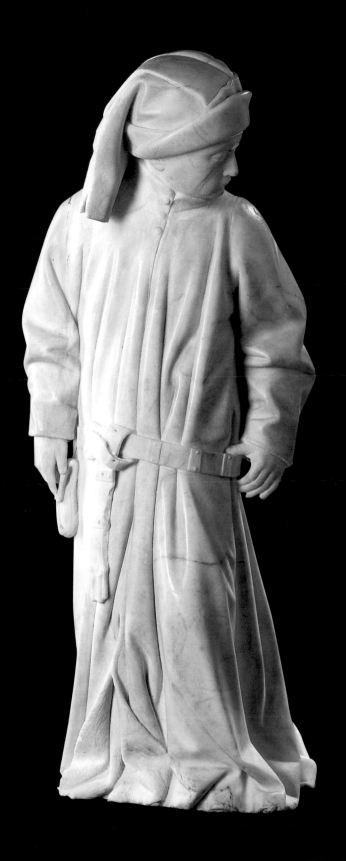
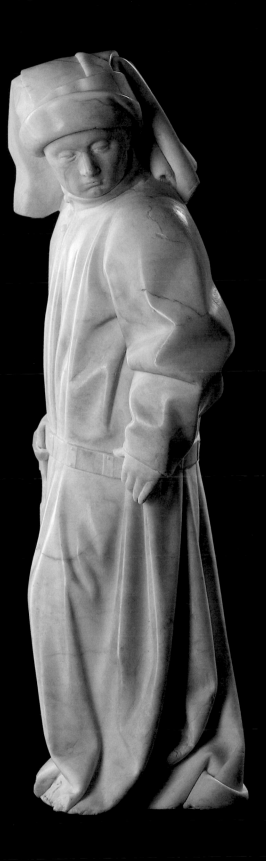

№ 57 mourner with cowl, left hand slipped into
his cincture, pouch at right

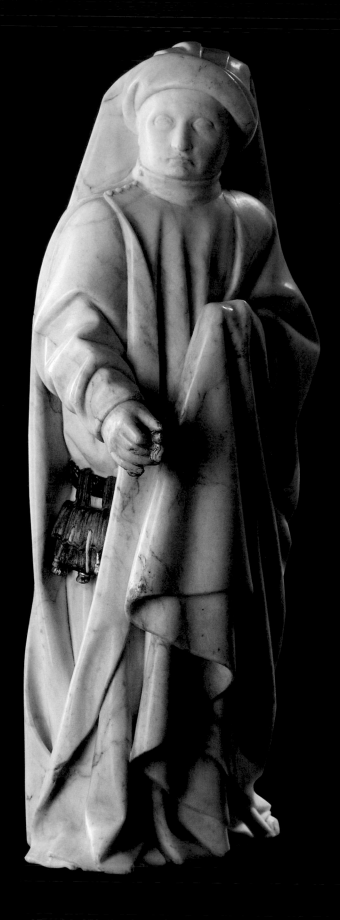

Nº 58 mourner with cowl, raising his left hand covered by
his cloak, pouch hanging from his cincture at right

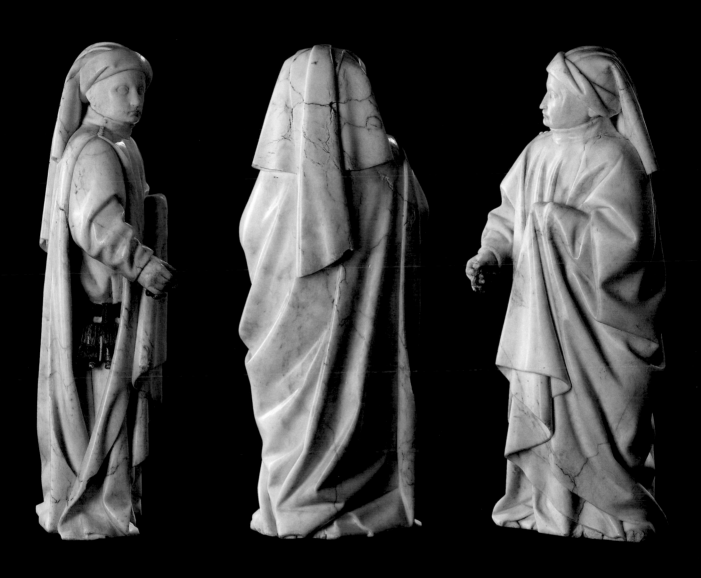

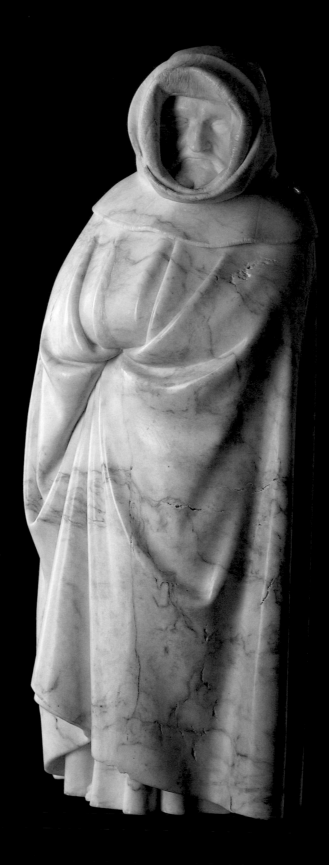

№ 59 mourner with cowl,
cloak bunched under his folded arms

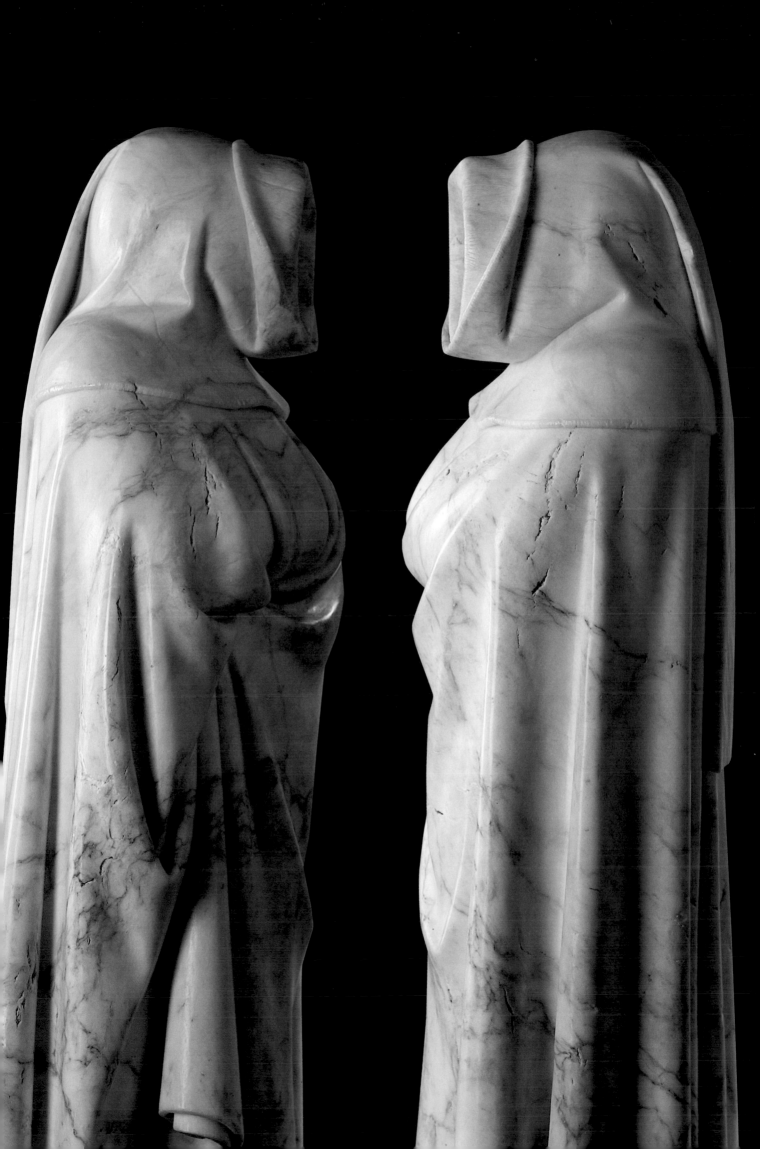

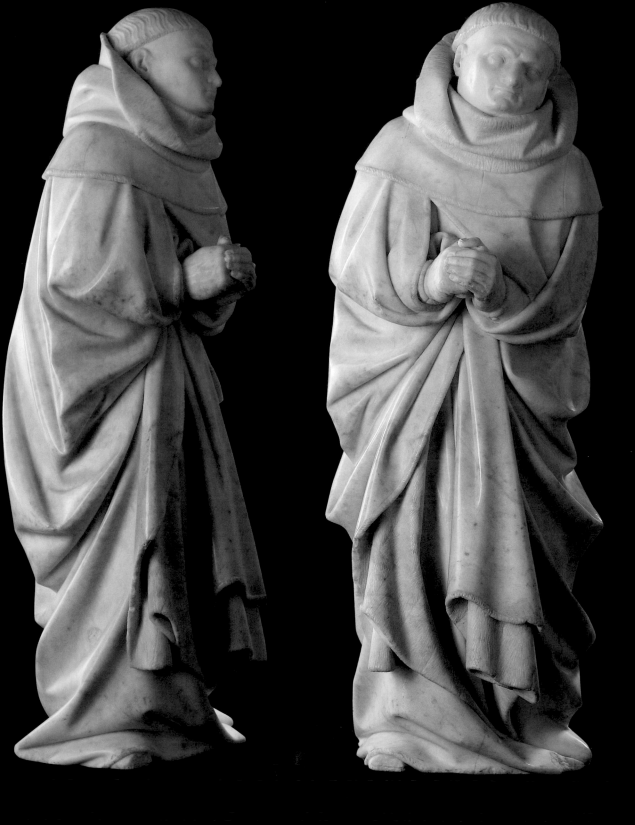

№ 60 mourner with head uncovered,
hands joined in front of his chest

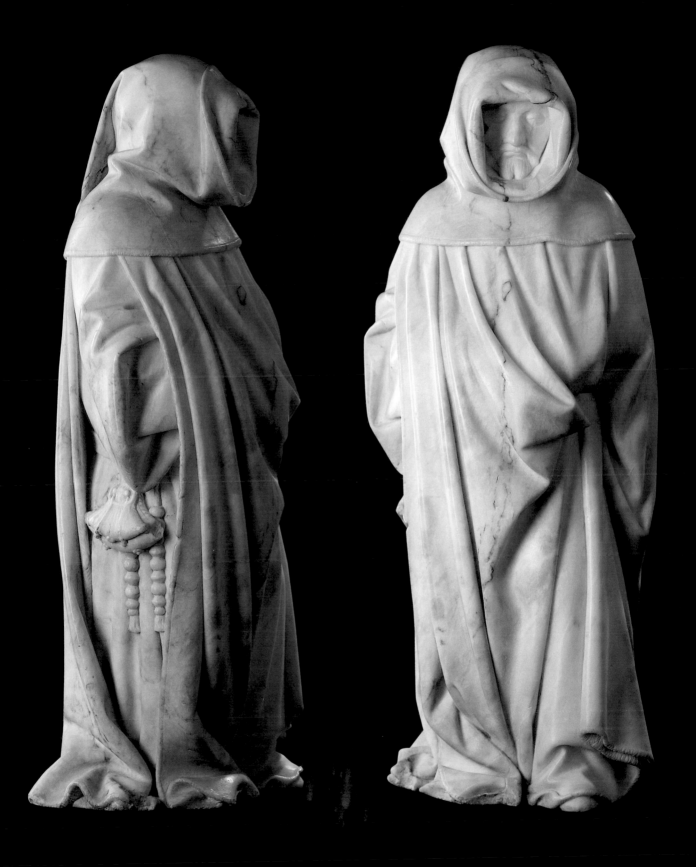

№ 61 mourner with cowl pulled down, hands beneath
his cloak, a pouch and rosary beads at right

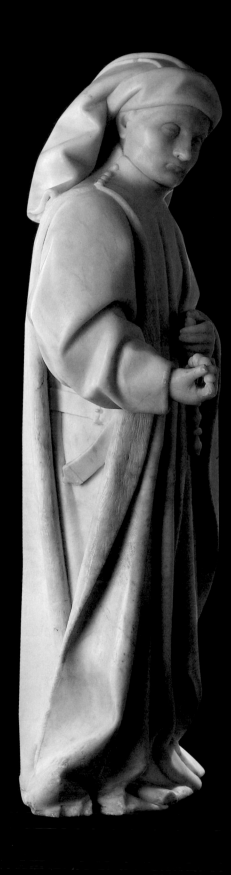
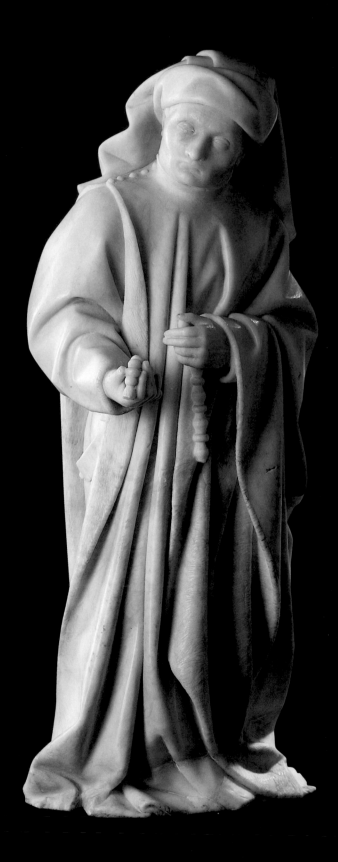

№ 62 mourner with cowl, holding rosary beads

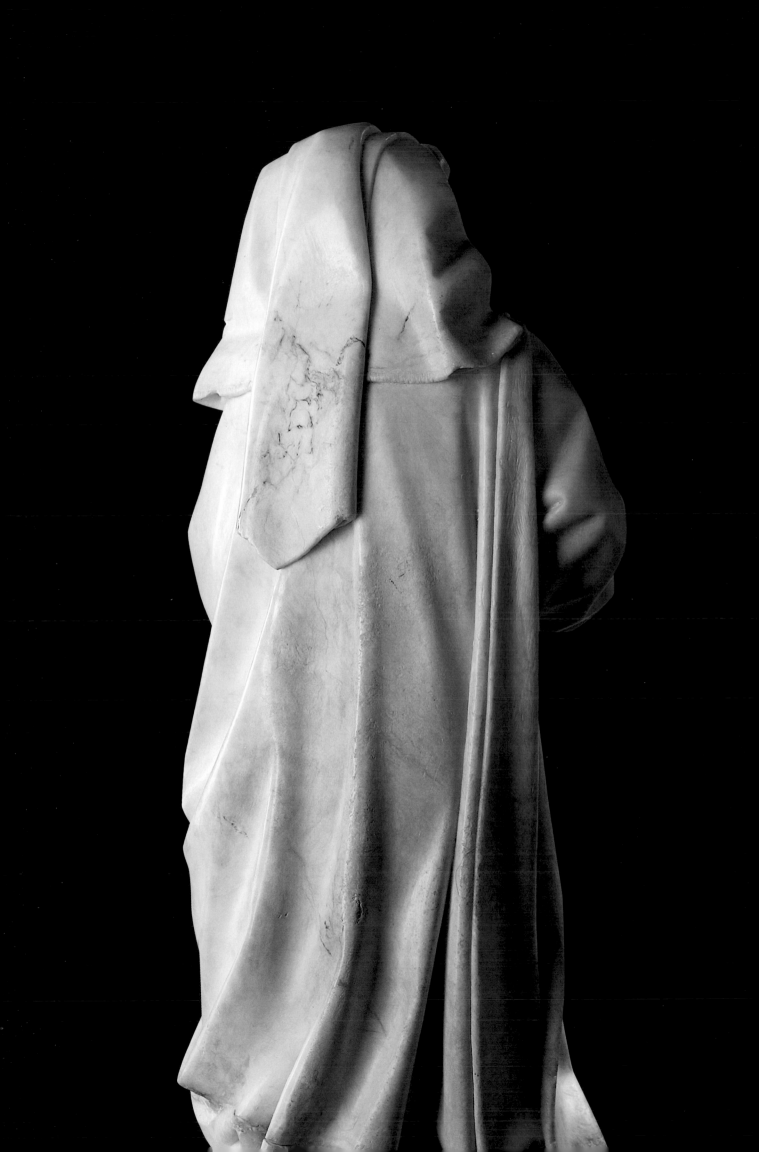

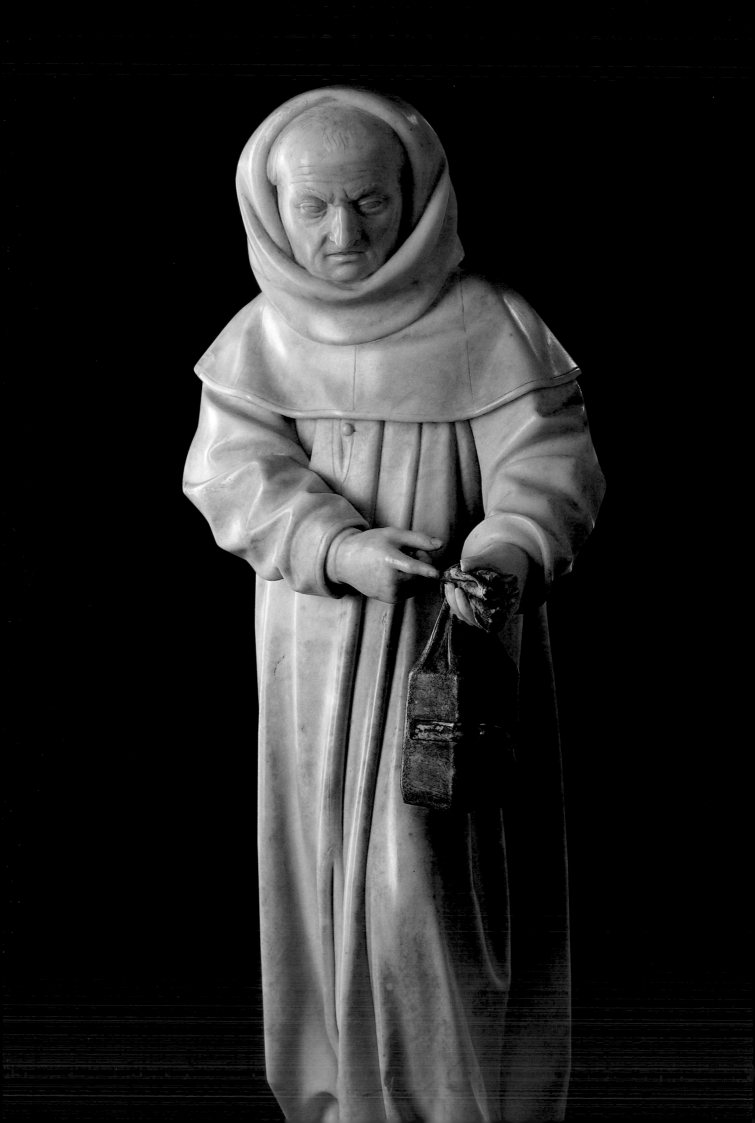

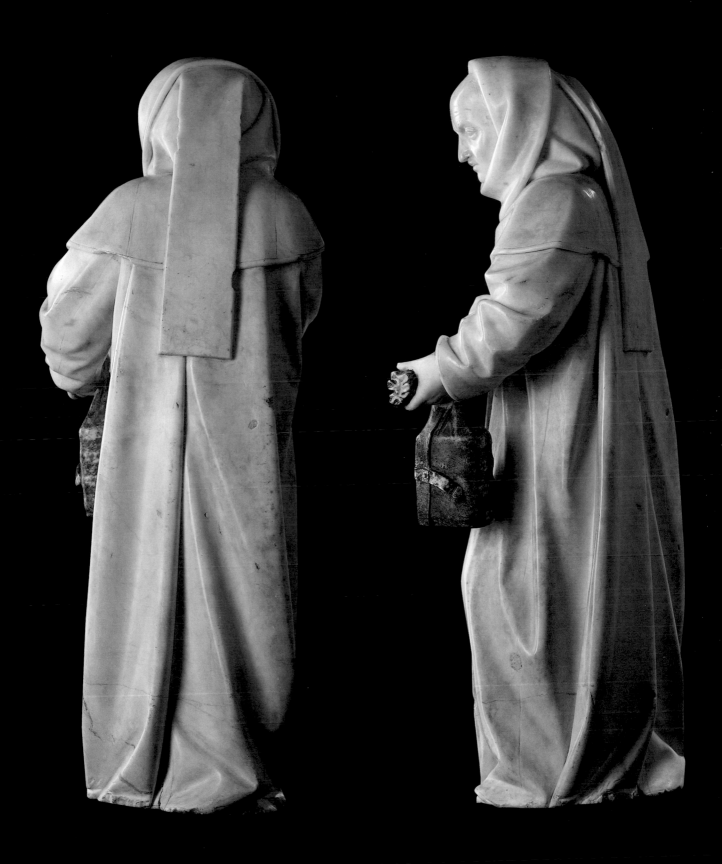

№ 63 mourner with cowl, right hand pointing to
the shrouded book in his left hand

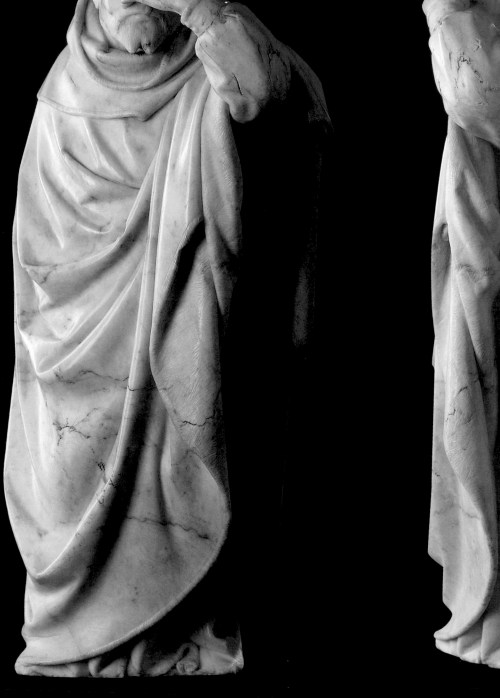

№ 64 mourner with head uncovered,
choking back his tears

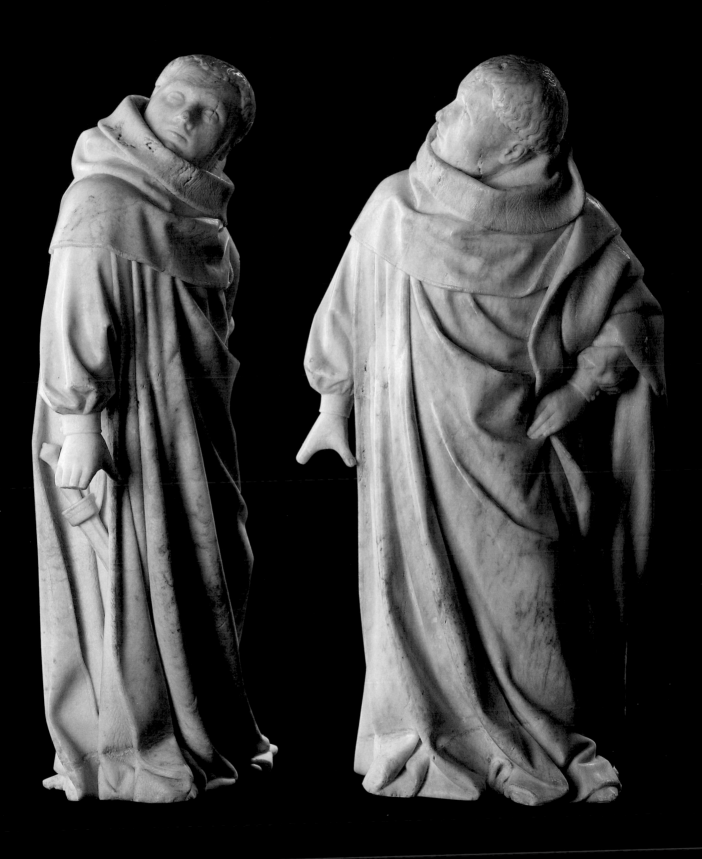

№ 65 mourner looking to the right,
right hand extended

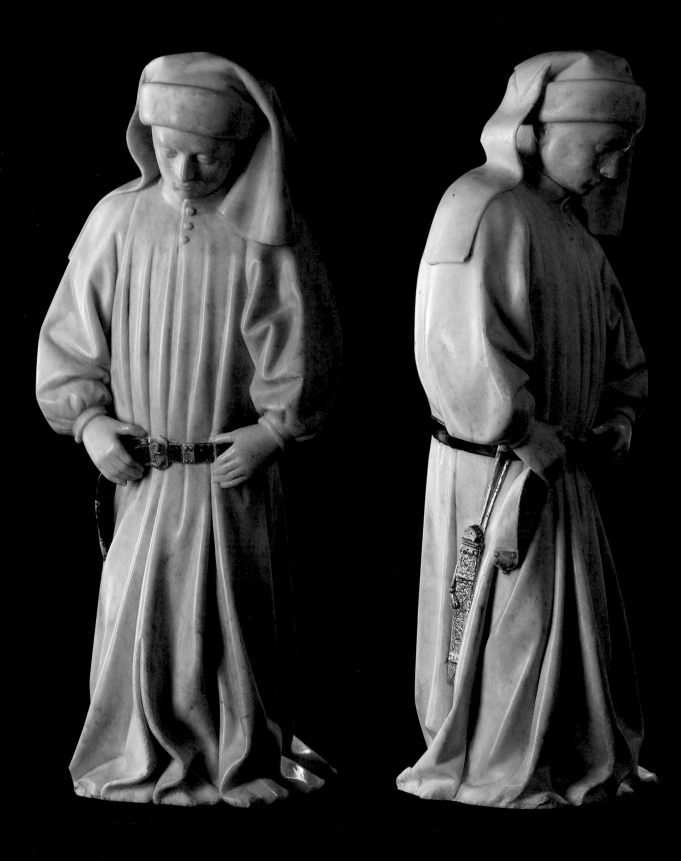

№ 66 mourner with cowl, hands in his cincture,
dagger at right

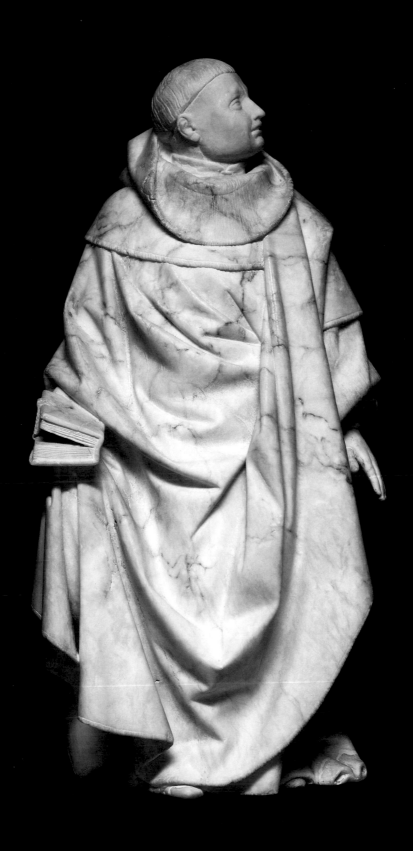

Nº 67 mourner with head uncovered,
a book in his right hand

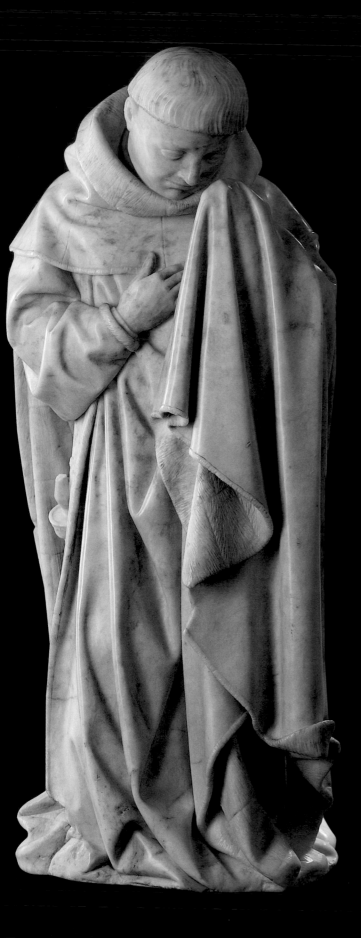

№ 68 mourner lifting a flap of his cloak to wipe away his tears, right hand on his chest, dagger at right

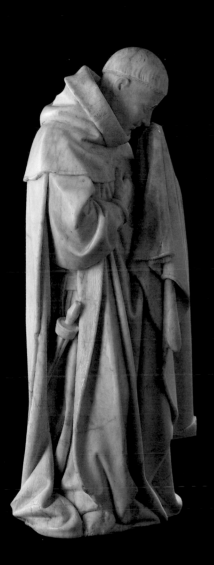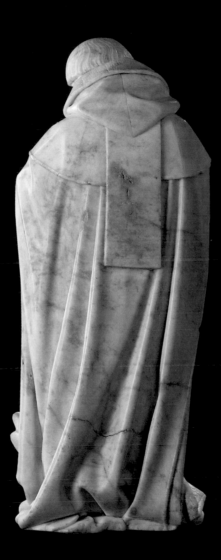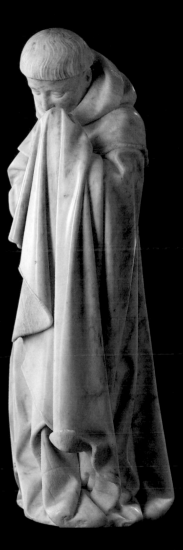

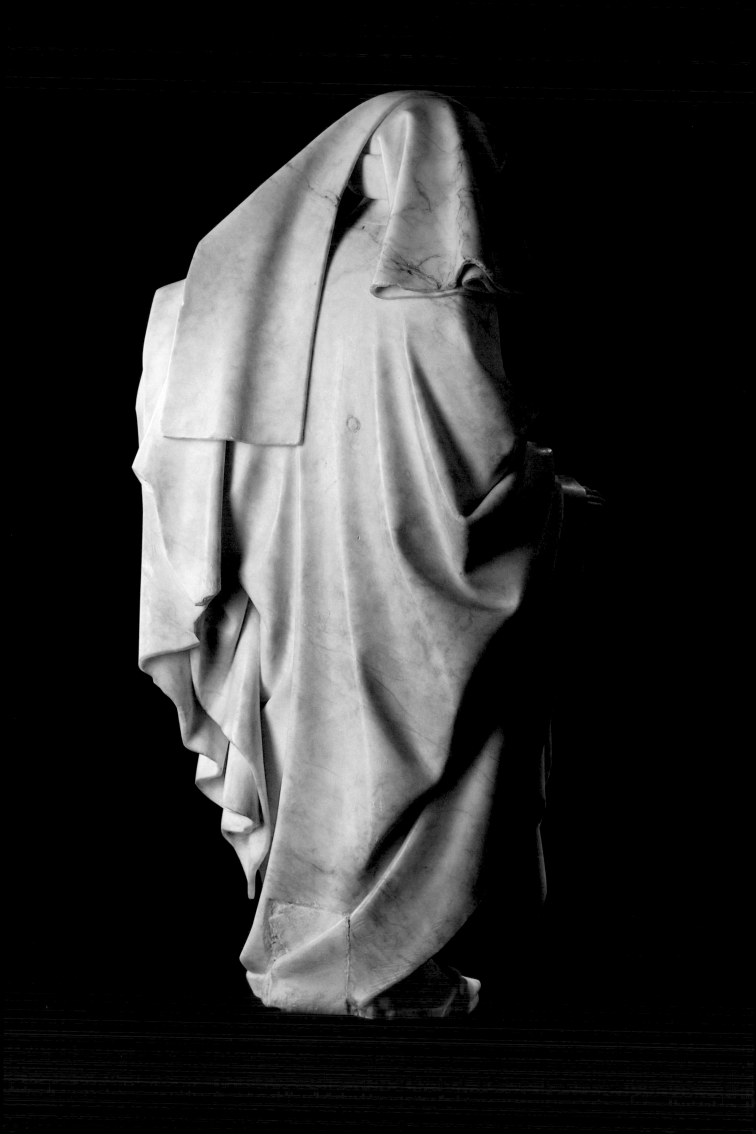

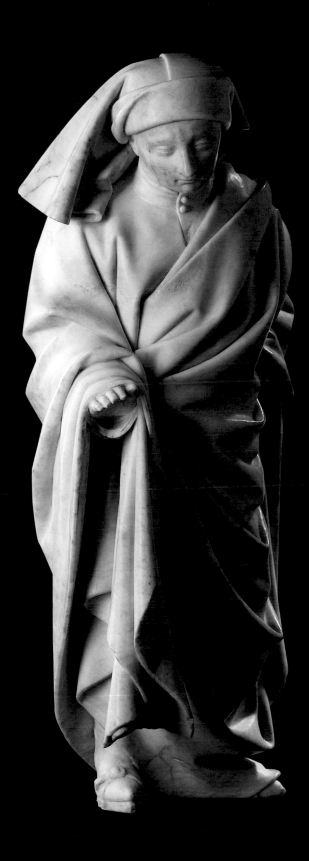
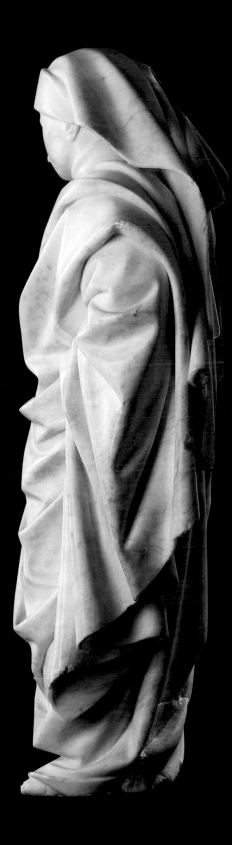

№ 69 mourner with cowl, right hand lifting
his cloak, left hand concealed

No 70 mourner with cowl pulled down,
left hand raised, right hand hidden
under a raised flap of his cloak

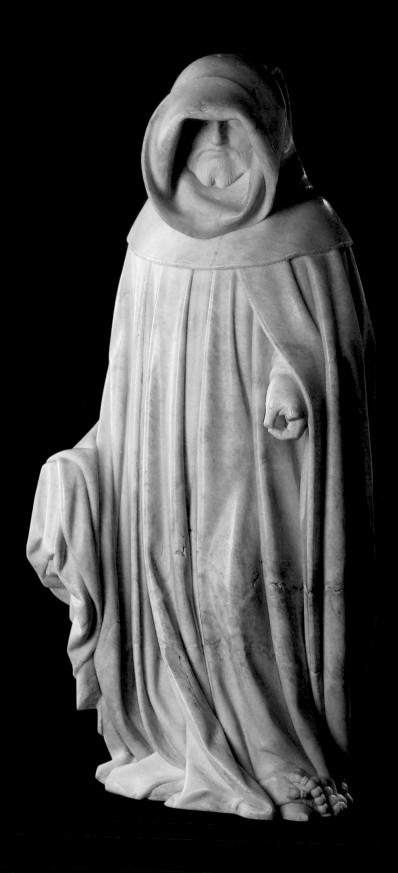

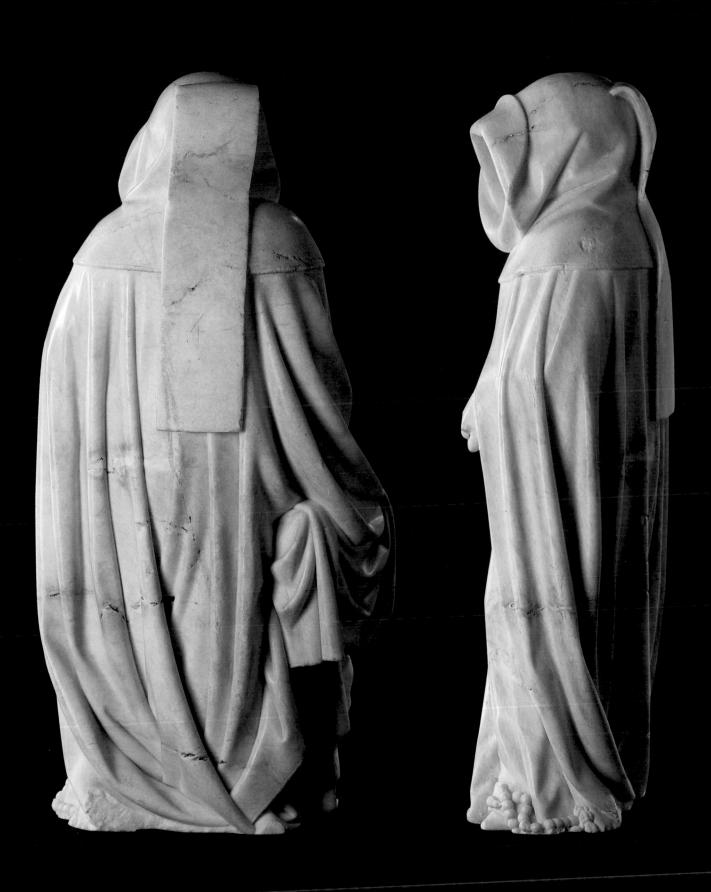

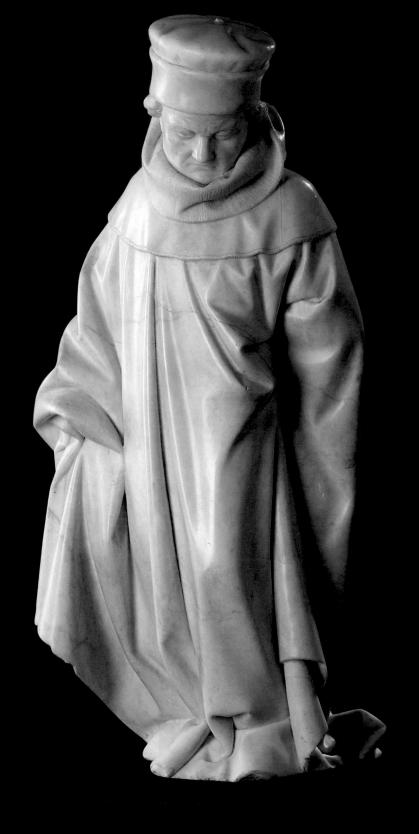

№ 71 mourner with cap, eyes lowered

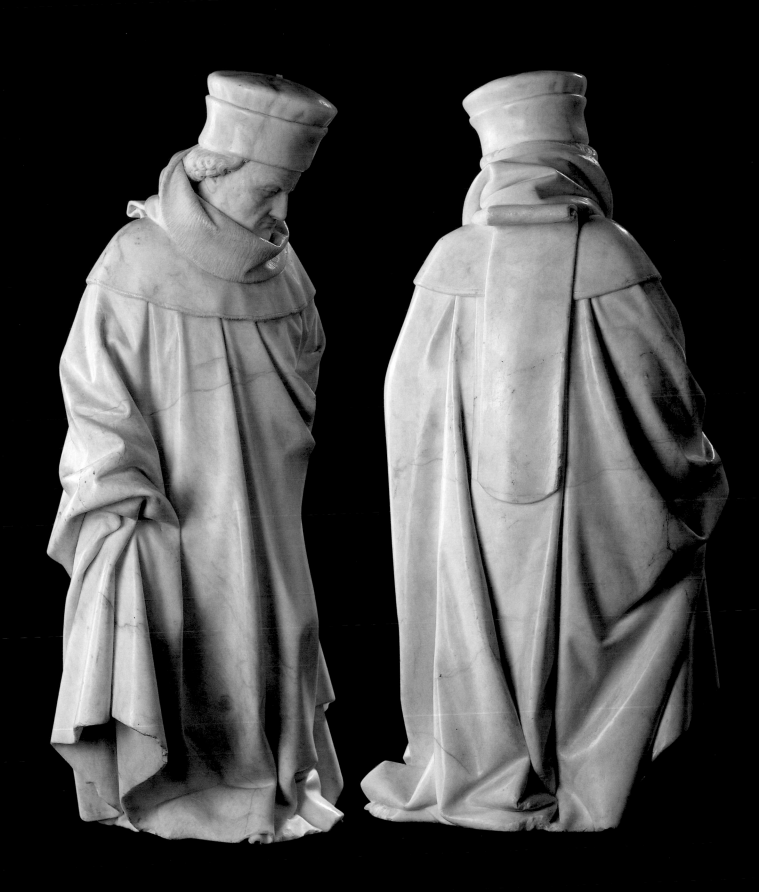

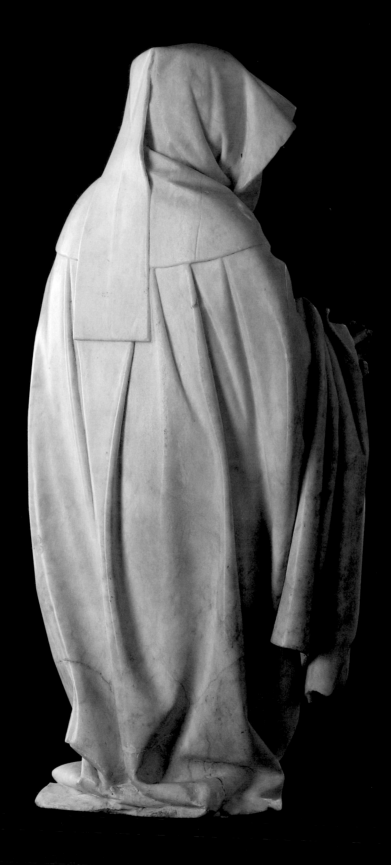

№ 72 mourner with cowl pulled down,
holding a rosary

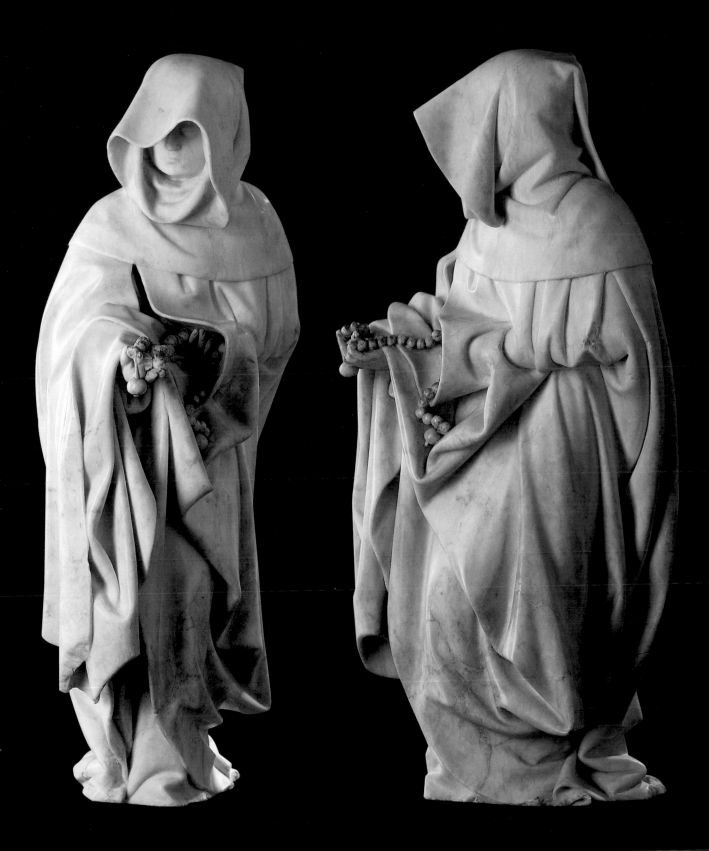

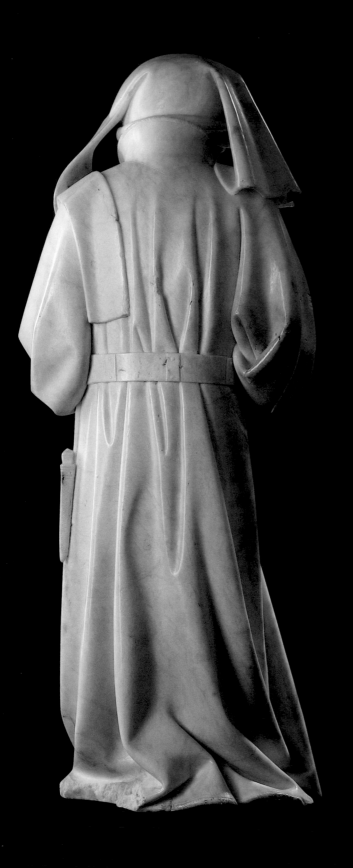
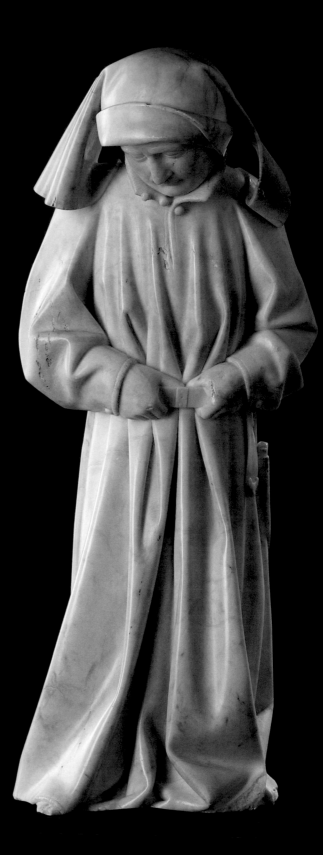

№ 73 mourner with cowl, both hands on his cincture, dagger at left

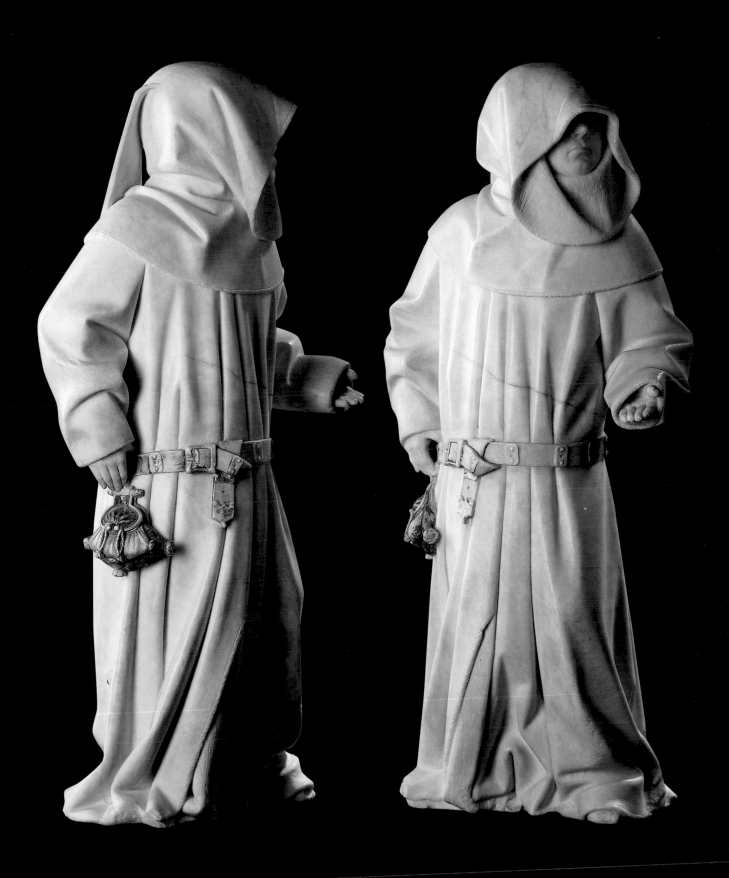

№ 74 mourner with cowl and cincture,
pouch at right

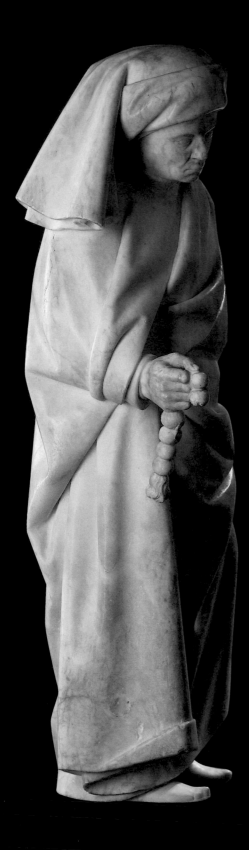
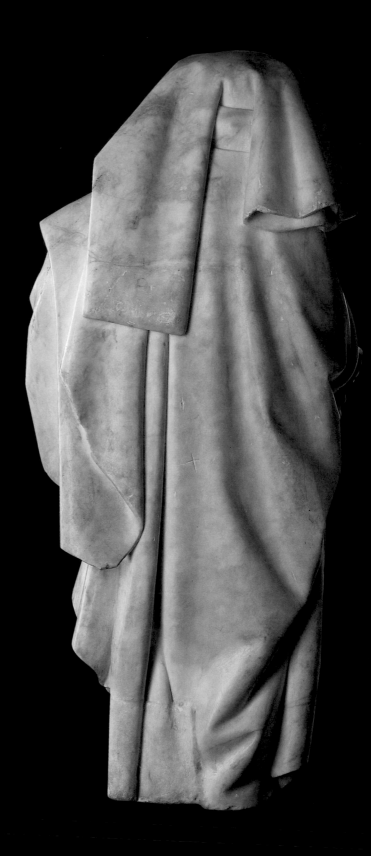

№ 75 mourner with cowl, holding rosary beads
in his right hand

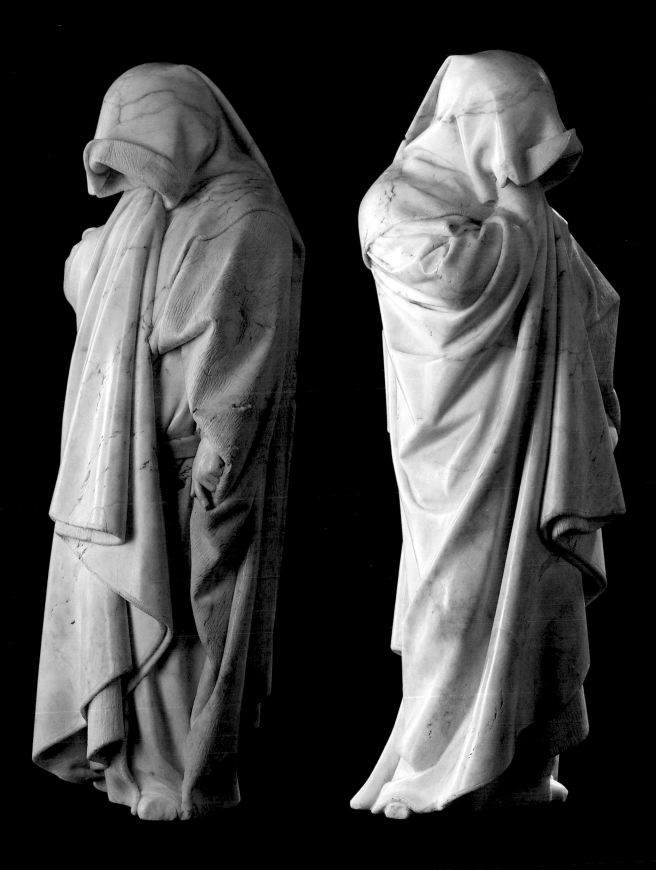

№ 76 mourner with cowl pulled down,
right hand lifting part of his cloak to his chin

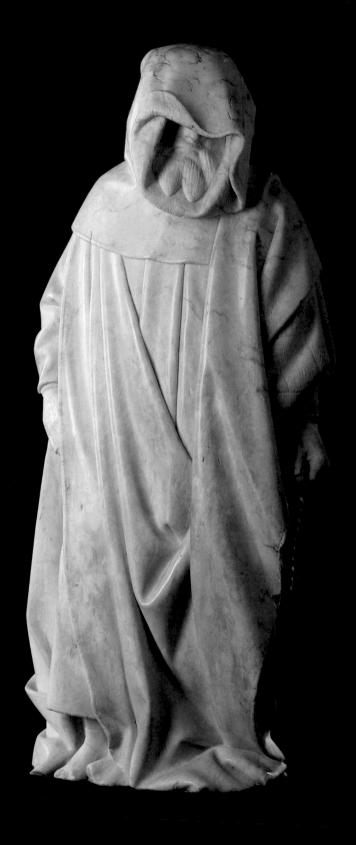

№ 77 mourner with cowl pulled down,
right hand in his cincture, left hand
holding rosary beads

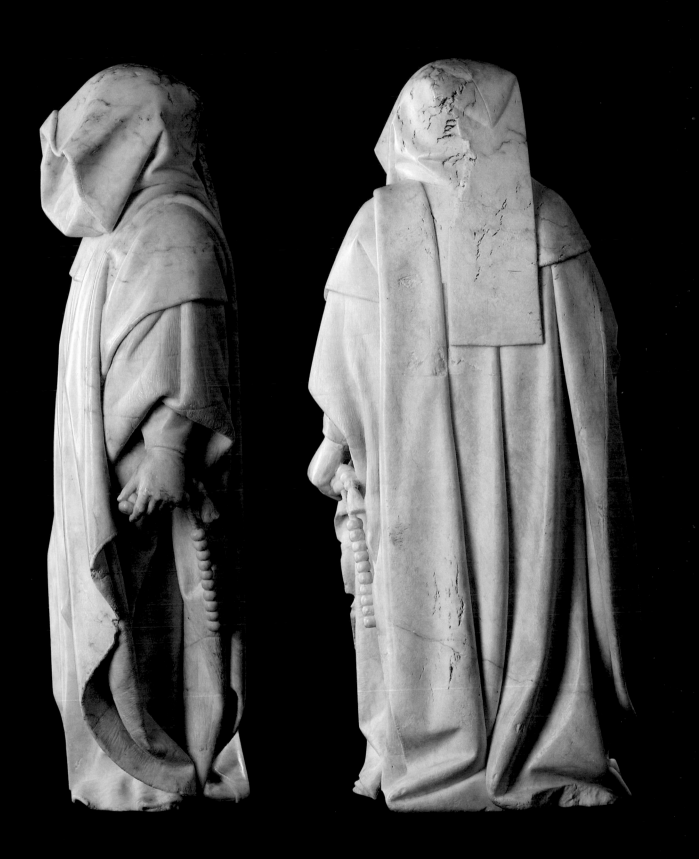

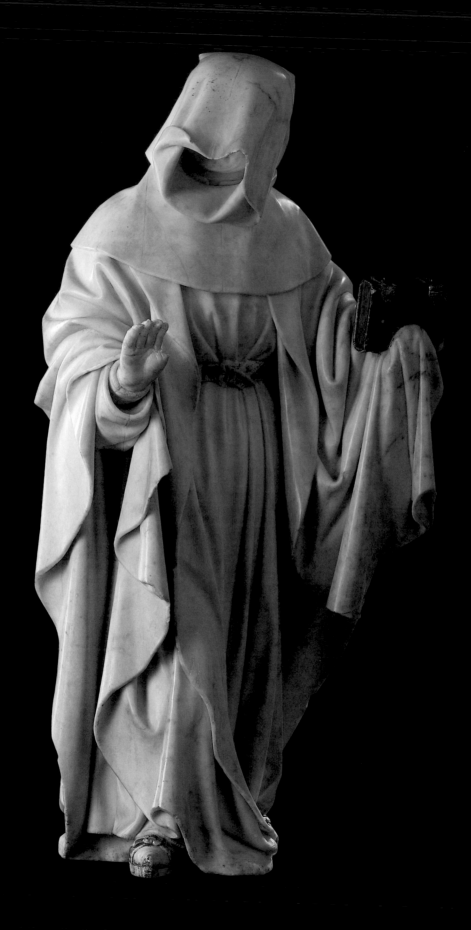

№ 78 mourner with cowl pulled down,
right hand raised, left hand holding a
book in a flap of his cloak

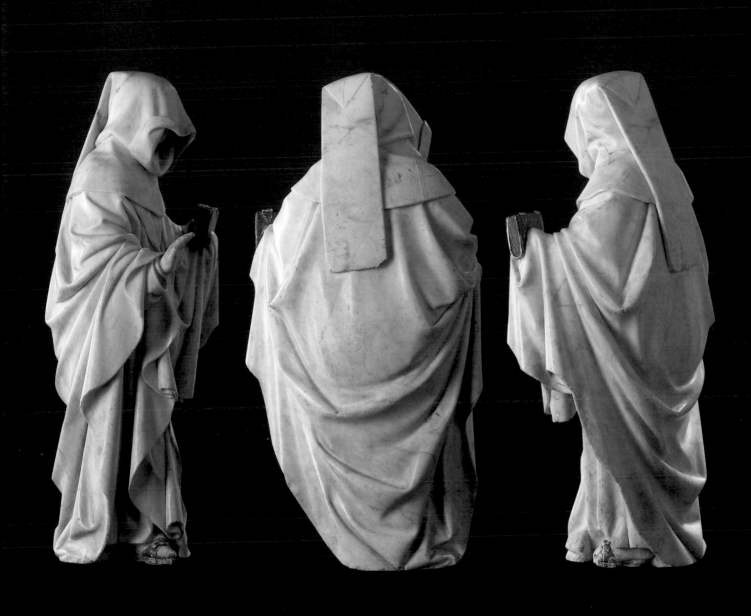

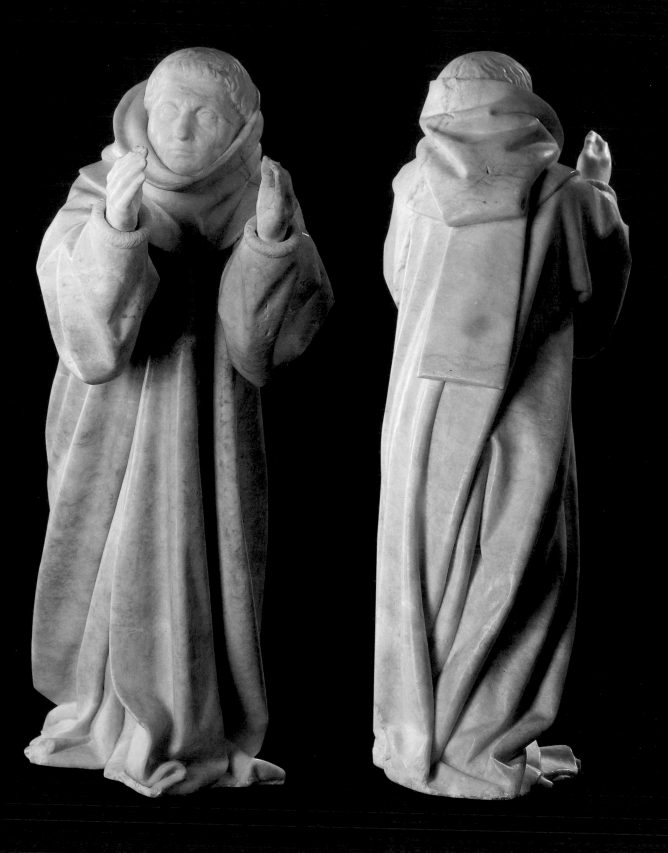

№ 79 mourner with head uncovered,
both hands raised

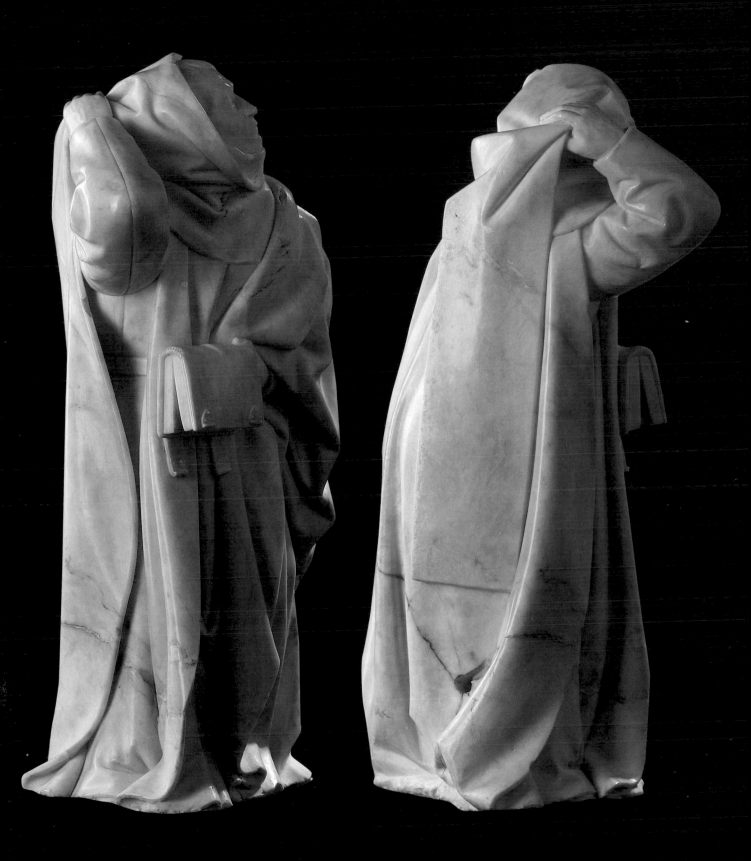

№ 80 mourner with cowl, holding a book in his
left hand, face raised heavenward

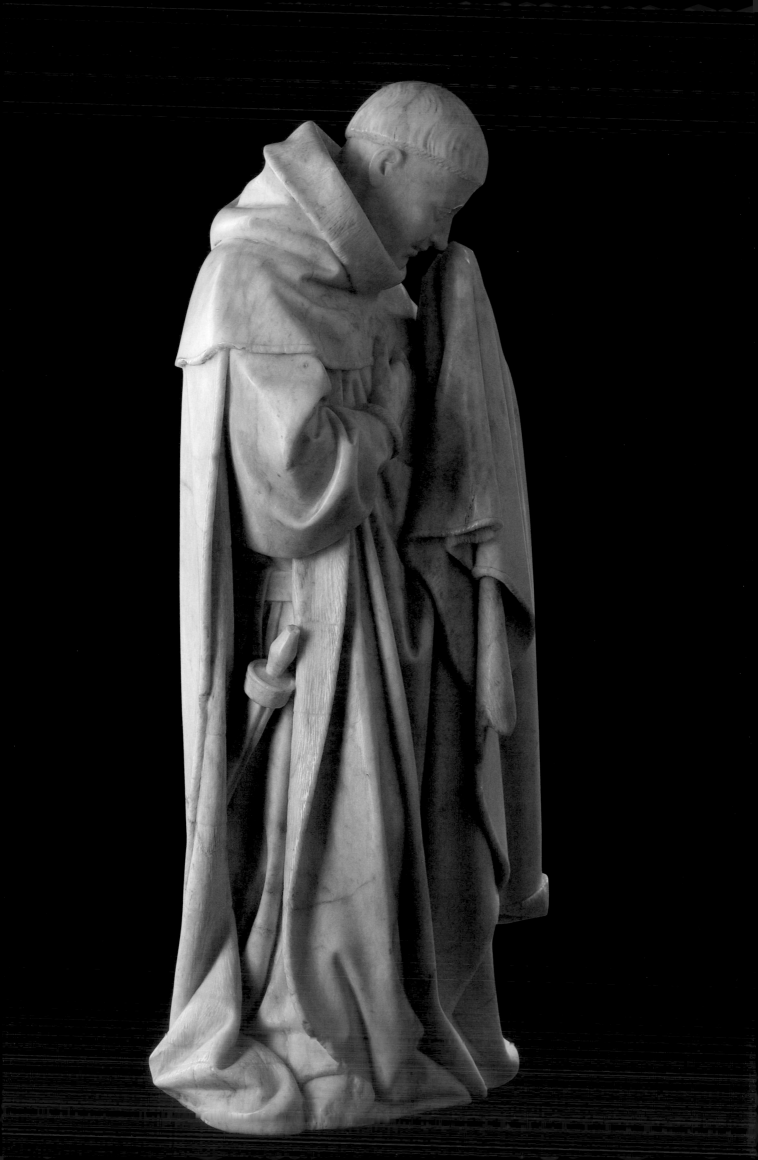

FROM CHARTERHOUSE TO MUSEUM

Tombs or Cenotaphs?

It is important to bear in mind that these monuments, though traditionally designated as tombs, are in fact cenotaphs; the dukes' coffins—it being customary at the end of the Middle Ages to embalm the bodies of princes—were buried in the cellars beneath the church chancel.

Only the first two dukes were honored with such a monument, which is readily explained by the history of their long, difficult, and costly execution. Philip the Good, who died in 1467, did not even live to see his father's tomb completed; and though he did express the wish for a tomb of his own, nothing was ever undertaken in that regard. His body and that of Isabel of Portugal were laid to rest in 1474 in a third cellar, with a simple epitaph.

A Dynastic Mausoleum

Whether or not Philip the Bold intended it, Champmol became de facto the dynastic mausoleum of the Dukes of Burgundy and their families: not only are the first three dukes and the wives of the second (Margaret of Bavaria, d. 1423) and the third (Isabel of Portugal, d. 1471) buried there, but also certain children of the successive dukes. Champmol has often been called the "Saint-Denis of the Dukes of Burgundy," in reference to the basilica of Saint-Denis, north of Paris, which housed the sepulchers of the French monarchs—first in the sixth century, then regularly from the thirteenth to the eighteenth centuries.[24] The Dukes of Burgundy are not the only noble dynasty to have built a dedicated necropolis: the same could be said of the Dukes of Bourbon in Souvigny, whose sepulchers, moreover, were the only princely tombs to remain standing after the rampant destruction of the French Revolution.[25]

Members of the Ducal Family Buried Away from Champmol

Seeing Margaret of Bavaria resting beside her husband, John the Fearless, we might wonder why we don't also find Margaret of Flanders next to Philip the Bold. The first duchess of Burgundy, countess of Flanders and Artois, remained true to her ancestors and elected to be buried with her father, Louis de Mâle, and her mother, Margaret of Brabant, in the church of Saint-Pierre in Lille. In 1453, Philip the Good erected a monument on the tomb of his forebears. The mourners, made of bronze rather than alabaster, depicted the lineage of Flanders and Burgundy; though he was the only one of the dynasty not to have a funeral monument, Philip knew quite well the dynastic value of these tombs. Around 1434, he had commissioned a tomb for his first wife, Michelle of France (d. 1422), at the abbey of Saint-Bavon in Ghent, and around 1436 one for his sister Anne, duchess of Bedford (d. 1432), in the church of Les Célestins in Paris. The wives of Charles the Bold were also buried far from Burgundy: Catherine of France (d. 1446) in Brussels, Isabella of Bourbon (d. 1465) in Antwerp, and Margaret of York (d. 1503) in Mechelen.

Charles the Bold concerned himself neither with his father's tomb nor with his own. It was his daughter Mary who in 1478 built the tomb of Isabella of Bourbon in Antwerp; the recumbent effigy and the bronze mourners still survive. The mourner theme is magnificently developed here in a series of figurines depicting members of the family. Charles the Bold, who died in Nancy in 1477, received a sepulcher in 1506 through the efforts of René II of Lorraine. In 1550, the Holy Roman Emperor Charles V ordered his body moved to Notre-Dame of Bruges, next to the tomb of Mary of Burgundy, which had been built in 1488–1502. The tomb was erected in 1558, decorated

with a heraldic motif in gilded copper. The cenotaph of Maximilian of Hapsburg in Ingolstadt (1556–83) forms a kind of apotheosis of the mourners theme, the life-size figures in this instance depicting members of the imperial family.

Dismantling and Destruction under the Revolution

While the Chartreuse de Champmol was sold off as national property in 1792, the tombs were kept for the Nation because of their historical value. In the seventeenth and eighteenth centuries, the tombs also attracted the curiosity of researchers, who wrote descriptions. The historical importance was underscored, but what always attracted the greatest curiosity were the mourners. They were deemed to possess a "correctness" rare for the Gothic period. Under the direction of the sculptor Claude François Attiret, they were dismantled and reassembled in the new cathedral, Saint-Bénigne, in June 1792.

On August 9, 1793, Dijon began doing away with all signs of the old feudal system; it was then that the recumbent effigies were destroyed. When Saint-Bénigne was rebaptized a "Temple of Reason," the tombs were again dismantled. The hands and faces of the mutilated effigies were removed, and the arcades, angels, and lions put in storage. During that period, several architectural details and some of the mourners disappeared or were acquired by collectors. Only seventy of the eighty mourners were transferred to the Musée des Beaux-Arts in 1794.

Nineteenth-Century Restorations

In 1819, the architect Claude Saint-Père took it upon himself to restore the tombs. He gathered up the pieces held in storage and sought out others that had passed into private hands. The missing portions were re-created by the sculptors Joseph Moreau (for the figures) and Marion de Semur (for the arcades): roughly one-third of the arcades, the recumbent effigies (to which they affixed the original faces and hands), and ten mourners, to replace the lost ones. Four of these ten were given the faces of the men overseeing the restoration (fig. 41). The

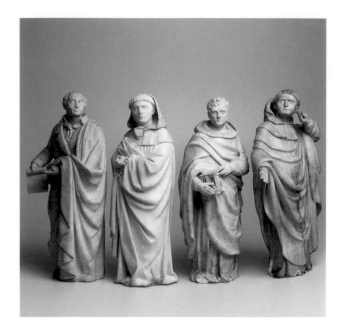

two tombs were finally reassembled in the Salle des Gardes of the ducal palace, which became part of the museum. The new display opened in 1827.

Twentieth-Century Improvements

In the years 1900–1930, it became clear that the order in which the mourners were placed was inaccurate: the correct placement was reestablished from eighteenth-century drawings. Also at that time, scholars began locating some of the missing mourners, which had gone into private collections. It was thanks to these efforts that in 1945 Pierre Quarré, the museum's curator, secured the return of three mourners from the Louvre, the Cluny, and the English collector Percy Moore Turner. The remaining seven mourners were not returned to Dijon: four had left France in the late 1930s and been acquired by the Cleveland Museum of Art, one is in a private collection, and two have apparently disappeared.

Further research in the 1990s led to the rediscovery in museums and on the art market of original architectural fragments that had eluded Févret de Saint-Mémin and Claude Saint-Père during their restorations. The museum

FIG 41 Joseph Moreau, Neo-Gothic Mourners, Portraits of Claude Saint-Père, Févret de Saint-Mémin, Joseph Moreau, and Marion de Semur; alabaster, H. each: 15¾ to 16½ in. (40 to 42 cm); Musée des Beaux-Arts, Dijon.

was able to acquire the original slab from the tomb of Philip the Bold (in 1991) and pendants from the canopies of Philip the Bold and John the Fearless (2001), and to receive on loan from the Musée des Arts Décoratifs a small column from the tomb of Philip the Bold and an incomplete canopy from the tomb of John the Fearless (2001).

The Restoration of 2003–05

Concerns over the many different ways the mourners were attached to the arcades of the two tombs—or sometimes not attached at all!—incited the museum's conservation department to equip the mourners systematically with a type of fastening that would ensure the works' security while still allowing them to be dismounted safely.

A very close study of the tombs on that occasion led to the conclusion that much more drastic action was needed than previously thought: the monuments, particularly the statues on the slabs, were encrusted with soot; and a number of flaws, such as adhesive that had turned brittle or overspilled its edges, or small gaps, also needed to be addressed (fig. 42).

Naturally, any work on such prestigious monuments requires study. The current studies have built on the solid foundation provided by Françoise Baron's research over the past two decades into the history of the tombs' nineteenth-century restorations, and on material observations previously made by the conservators.

The most important of these observations had been formulated by Jean Délivré. Whereas medieval sources spoke of "alabaster stone" for the arcades on Philip the Bold's tomb, he had drawn our attention to the fact that the original canopy, acquired in 1991, was made of marble (fig. 43). This is a crucial observation, since the nineteenth-century documents specify that the restorations used alabaster. A systematic chemical test of every element of the arcades allowed Annie Blanc, an engineer in the research laboratory at the Office of Historic Monuments, to establish a comprehensive schematic of the monument.

The preliminary study, headed by Benoît Lafay, was followed step by step by the museum's conservators, seconded by a scientific committee comprising representatives from

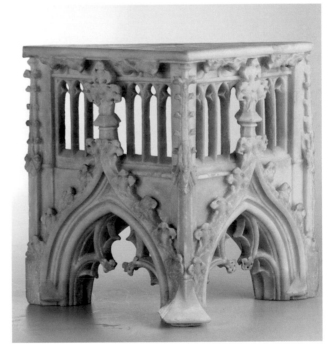

FIG 42 Tomb of Philip the Bold before restoration. A grayish film covers the entire work.

FIG 43 Tomb of Philip the Bold, original marble canopy, 8⅞ × 10¼ × 6⅝ in. (22.5 × 26 × 17 cm); Musée des Beaux-Arts, Dijon.

44

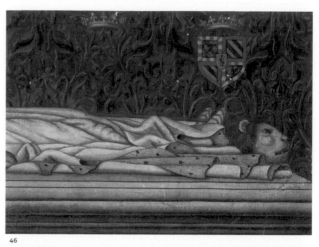

46

42

45

47

the sculpture department of the Louvre, the research and restoration department of the Musées de France, and the Office of Historic Monuments, along with certain members of the committee who had followed the restoration of the Well of Moses (1999–2003).

The study[26] led to several important discoveries and many observations vital to the restoration:

- a comprehensive schematic of the components and the materials used;
- observation of traces of the original lead mounting (figs. 44 and 45) and of the way the work was reassembled in the museum in the nineteenth century;
- a side-by-side comparison of various written and iconographic sources seconded by direct observa-

tion of the works, which notably led researchers to realize that the recumbent figures were smaller than the ones re-created in the nineteenth century, and that the lions were caught in the folds of the mantles (figs. 46 and 47);
- a study of the polychromy, which retains only sporadic traces of the original layer but nonetheless attests to the overall accuracy of the nineteenth-century restoration (figs. 48 and 50a, b);
- a comprehensive report on the state of the work's constituent elements;
- studies to determine a permissible degree of cleaning.

FIG 44 Tomb of John the Fearless, pillars of single canopies from the full-sized tracing of the seating.

FIG 45 Tomb of John the Fearless, base of mourner no. 42, showing sprue for the lead seal and star-shaped cracks in the alabaster around the casting hole.

FIG 46 Tomb of Philip the Bold, side II, from a drawing by Lesage, showing the lower portion of the recumbent effigy (detail; see fig. 25b).

FIG 47 Tomb of Philip the Bold, side II of the current state, showing the lower portion of the recumbent effigy.

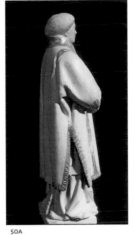
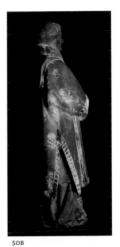

48

50A

50B

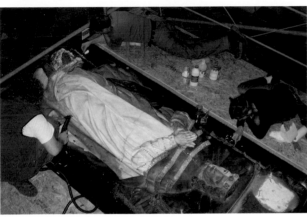
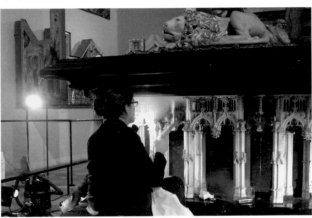

49

51

Original to the tomb of Philip the Bold are the angels, the helmet, the lion, the duke's hands, the side flaps of his mantle, the slab, parts of the underlying slabs, roughly two-thirds of the arcades, all the mourners (except for plaster casts of the ones located outside of Dijon), and the base. The duke's recumbent effigy and one-third of the arcades are re-creations.

Original to the tomb of John the Fearless are the angels, the helmet, the shield, the lions, the faces and hands of the duke and duchess, the side flaps of the mantle, roughly two-thirds of the arcades, all the mourners (except for a plaster cast of the one located outside of Dijon), and the base. The slab, the recumbent effigies of the duke and duchess, and one-third of the arcades are re-creations.

A further goal of the study was to suggest approaches for the tombs' restoration, bearing in mind their overall condition. The restoration's guiding principle is to high-light the homogeneity of the monuments while respecting the contributions of the nineteenth century.

The first tomb restored was Philip the Bold's, in late 2003–early 2004 (fig. 49). Restoration of the tomb of John the Fearless and Margaret of Bavaria followed in late 2004–early 2005. The two tombs were thoroughly cleaned, using various methods depending on the area needing treatment (figs. 51, 52, and 53). Old or brittle adhesives were replaced, and some losses filled in (figs. 54 and 55). After the tombs were cleaned, some polychromatic areas revealed noticeable alteration, mainly in the polychromy

FIG 48 Tomb of Philip the Bold, side I, from a drawing by Lesage, showing original polychromy.

FIG 49 Tomb of Philip the Bold, late 2003–early 2004 restoration.

FIG 50A,B Tomb of Philip the Bold, mourner no. 4 in natural light and under ultraviolet light, which reveals the original decorations, invisible to the naked eye (photo in ultraviolet light by Jean-Pierre Bozellec, LRMH).

FIG 51 Tomb of Philip the Bold, final state of cleaning the arcades. Steam removes any remaining encrustation on inaccessible areas in the deep recesses.

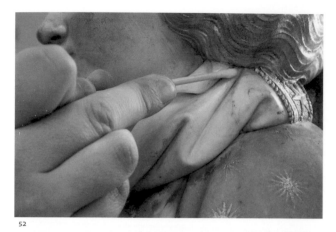

52

54

53

55

from the nineteenth century. This required fairly signifi-
cant retouching to bring the color on those areas in line
with the rest. The stucco slab of John the Fearless's tomb
had faded, and was repainted black and waxed to restore its
similarity to the black marble slabs (fig. 56). Both tombs in
their entirety were given a protective coating of antistatic
microcrystalline wax that keeps dust from sticking and
thereby facilitates maintenance.

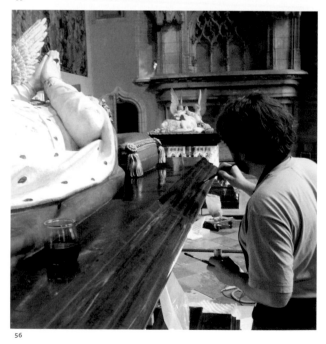

56

FIG 52 Tomb of Philip the Bold,
cleaning an angel.

FIG 53 Tomb of Philip the Bold,
cleaning the recumbent figure.

FIGS 54 AND 55 Tomb of Philip the
Bold, old or brittle adhesives were
replaced, and some losses filled in.

FIG 56 Tomb of John the Fearless,
the stucco slab being repainted black
and waxed to restore its similarity to
the black marble slabs.

THE SALLE DES GARDES: BURGUNDY'S *LOCUS MEMORIAE*

The Salle des Gardes (guards' hall) of the Musée des Beaux-Arts in Dijon (fig. 57) is one of the city's most deservedly celebrated tourist attractions.[27] Witness this passage from the August 11, 1899, issue of *Le Progrès*, while the hall was being restored:

> When, o when, will our tomb gallery be reopened for the public's admiration? Everyone is clamoring for it. . . . The innkeepers of Dijon will tell you: visitors from London, Paris, or Germany en route to Italy have much greater museums than ours to look forward to. What they come to Dijon to see is the Salle des Gardes.

The huge hall, which measures 29½ feet (9 m) floor to ceiling, 59 feet (18 m) in length, and 29½ feet (9 m) in width, is exceptional indeed. With its imposing, flamboyant Gothic-style fireplace, it served as the main banquet hall of the palace built by Philip the Good in the mid-fifteenth century. Also exceptional is the display of the tombs of Philip the Bold and John the Fearless, signal monuments of Burgundian sculpture from the fourteenth and fifteenth centuries. Though no longer located in the Chartreuse de Champmol, the building for which they were designed, there is no doubt that the sepulchers of the first two dukes have found a worthy setting in the palace of the third.

Whereas Claude Saint-Père, the architect who undertook the tombs' restoration, intended to reinstall them in Saint-Bénigne, it was Févret de Saint-Mémin, the museum's curator from 1817 to 1852, who thought to put them in the Salle des Gardes. The latter had become part of the Dijon museum in 1820 to house an imposing work of sculpture, the funeral monument of the poet Prosper Jolyot de Crébillon. Resting on the Gothic arches of the palace's lower hall (now the civil wedding hall), the floor of the Salle des Gardes, one flight up, was solid enough to support the imposing marble and alabaster mausoleums.

The hall has been known as the Salle des Gardes since the time when the governors of Burgundy, as the king's provincial representatives, occupied the palace (then called the

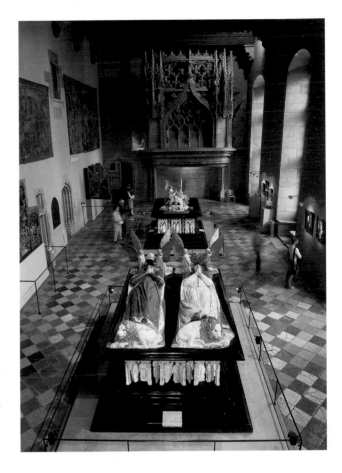

King's Lodgings); it was in that hall that the guards stayed. It has been transformed several times over the centuries. After a fire that ravaged the upper portions of the palace in 1503, the fireplace and ceiling were rebuilt. In 1548, on the occasion of Henry II's entry into Dijon, they rebuilt the musician's rostrum and decorated it with his emblems. In 1711, as part of a project designed by Jules Hardouin-Mansart, the hall was redecorated with cornices, woodwork, and tapestries with fleur-de-lis patterns that gave it a more classical look, in keeping with the rest of the palace. It was restored by Févret de Saint-Mémin in the neo-Gothic style, with particular concentration on the fireplace.

It was in 1827 that the restored tombs were installed there, as were, a little later, the carved, gilded wooden altarpieces from the Chartreuse de Champmol. In a France

FIG 57 Salle des Gardes, Musée des Beaux-Arts, Dijon.

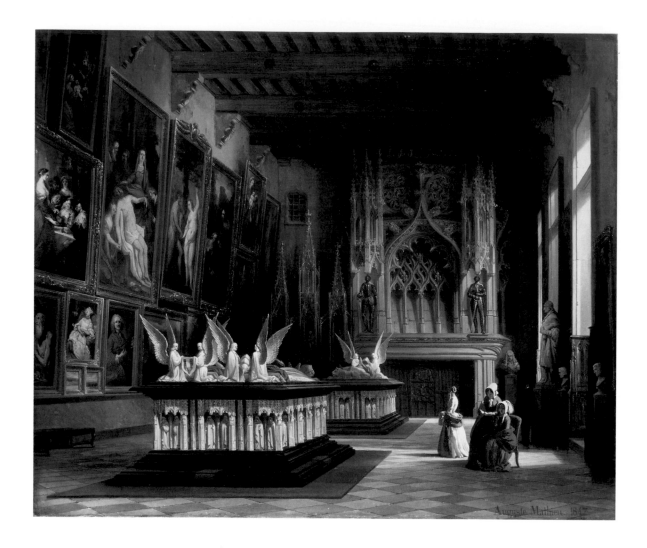

just beginning to rediscover its medieval past, which the modern era had ignored and the Revolution had trampled, the "Hall of the Dukes of Burgundy" was considered exemplary. Victor Hugo and Stendhal were among its visitors. It became at the time—and still is today—an obligatory stop for tourists and distinguished guests of the municipality, as witnessed by the watercolor immortalizing the "visit to the tombs" by the Emperor Napoleon III and the Empress Eugenia in 1861.

But the hall's historical resonance did not stop at the Middle Ages: it also contained busts and statues of "illustrious Burgundians" through the centuries, such as Crébillon,

Bossuet, Rameau, Buffon, and many other members of parliament, magistrates, clergy, writers, scientists, artists, and political figures who constitute the "Dijon pantheon." This was well understood by Théodore de Jolimont in his *Description de Dijon* of 1830: "This room, with its decorations and statues dating from the fifteenth and sixteenth centuries, is mainly intended to bring together ancient and modern monuments relating to the history and famous figures of the city of Dijon or old Burgundy, and in itself forms a kind of local museum, the idea behind which is felicitous and should be imitated."[28] The 1847 canvas by Auguste Mathieu (fig. 58) offers a view of the hall in the Romantic

FIG 58 Auguste Mathieu (1810–1864), *The Salle des Gardes at the Dijon Museum in 1847;* oil on canvas, 37¾ × 45¼ in. (96 × 115 cm); Musée des Beaux-Arts, Dijon.

period. One can recognize the tombs and make out the illustrious Burgundians, along with the most important paintings in the collection—not all of which actually hung in that gallery.

The museum's archives contain photos that allow us to retrace the evolution of the various displays in the nineteenth and twentieth centuries. On a picture from about 1894, we can see how densely packed and heterogeneous it was, in the style of the times. From 1895 to 1900, the palace underwent a complete restoration by the Office of Historic Monuments. The hall, rough-coated in red and fitted out with neo-Gothic woodwork, reopened in the summer of 1900—empty. The effect was deemed frigid, and the artworks were reinstalled in an arrangement just as overloaded as before. After World War II, Pierre Quarré, who served as the museum's curator from 1938 to 1979, initiated a major overhaul that lasted from 1945 to 1951. The Salle des Gardes, which reopened in 1945, looked nothing like it had in 1939. Rough-coated in light earth tones, the neo-Gothic woodwork and railings removed, it now housed only those objects directly related to the Dukes of Burgundy. Some slight modifications aside, this is the look it retained until its closing in 2009 for the museum's current renovation.

At long last, the gallery has truly become the "Hall of the Dukes of Burgundy"—even though this name, which was originally proposed by Févret de Saint-Mémin, never really caught on, not even after Pierre Quarré reorganized the space and even though it more aptly described the contents. The space is also called the Gallery of the Tombs. But Salle des Gardes is still the most common designation, a sign that the former palace remains a strong presence in the museum.

Despite the museum's renovation, the Salle des Gardes will of course change none of its function. The museum's annexation of new spaces leaves it free to place only the tombs and altarpieces in the gallery, in keeping with the monumentality of the space. The other works relating to the Dukes of Burgundy have been moved to adjacent rooms, fitted out with pedagogical apparatus that allow a better understanding of the importance and artistic significance of the age of the dukes. The gallery itself, which took a back seat in the earlier display, can thus be better highlighted, especially its fireplace, which, once cleaned, will again stand out on walls restored to their proper colors.

Conclusion

As we reach the end of this history that has led us through more than six centuries, it is impossible not to recall the many individuals who have engaged with the tombs of Philip the Bold and John the Fearless: the four dukes of Burgundy; their wives, children, and descendants; the nobles of the period; the merchants who supplied the marble and alabaster, the artists who sculpted and painted it, and the workers who transported and assembled it; the Carthusians who prayed for the dukes' souls for more than four centuries; the visitors to the charterhouse; the kings and queens of France making their ceremonial entrance into Dijon; the citizens discovering the newly opened charterhouse during the Revolution; the man who bought the property; the marble-workers and sculptors who moved and restored the tombs, and the collectors and dealers who acquired their component parts; the curators who have watched over the mourners and the tombs, the many art historians who have studied them, and the conservators who recently restored their splendor; and finally all the museum visitors, illustrious and otherwise, who have come to admire them—several million people since the year 1799! Still, the power and quality of these small figures is such that we can appreciate them without recourse to this accumulated knowledge, heedless of the many eyes that have viewed them before us.

Today, the museum's renovation offers a unique occasion to remove the mourners from their architectural setting. Whether in Dijon (for Philip the Bold's mourners) or in America and Paris (for those of John the Fearless), this is a once-in-a-lifetime opportunity to admire them in an open space, on their own merits.

Now it is up to you—provided you are willing to let these objects work their magic—to indulge in the long contemplation they elicit and to succumb to the fascination that

their unity and diversity inspire. If I may suggest a way of going about it (and I can guarantee from experience that it will keep you occupied for quite some time if you follow it seriously):

- Look for the figures with heads covered and faces completely hidden, those wearing a cowl but whose faces are visible, and those with heads uncovered; study their faces, hair, and beards, their sorrowful expressions, and in some cases their tears;
- Look for the hands: some have neither hand showing, others only the right or the left, and still others both; they might be raised, joined together, covered, twisted, or tendered in consolation;
- Note the different garments and accessories depicted, on both the clergy (robes, crosses, candles, sacred texts) and the laypersons (prayer books, rosaries, cinctures, daggers, purses, and details that hint at the refinement of the figure's clothing beneath the mourning cloak—shoes, socks, sleeves, buttons, furs, thickness of fabric—as well as at his social standing);
- Look more closely at the fabrics, some with deep folds or falling straight, others rolled, rumpled, or creased; imagine the prodigious talent required to create all of that from alabaster;
- Examine each individual figure, whether lost in thought or communicating in some way with his neighbors;
- Walk alongside the procession, and bear in mind that it is they who walk in perpetuity, eternally mourning their duke.

Notes

1. *Palais des ducs et Palais des états de Bourgogne,* exh. cat. (Dijon: Musée Municipal, 1956), 10.

2. Susie Nash, "Claus Sluter's 'Well of Moses' for the Chartreuse de Champmol Reconsidered," *The Burlington Magazine* 1, no. 147 (December 2005): 798–809; 2, no. 148 (July 2006): 456–67; 3, no. 150 (November 2008): 724–41.

3. Isabelle Denis et al., "La restauration du Puits de Moïse, Chartreuse de Champmol, Dijon, Côte d'Or," *Monumental* no. 2 (2004): 26–45; Michel Huynh, Sophie Jugie, and Judith Kagan. *La chartreuse de Champmol et le Puits de Moïse* (Paris: Éditions du Patrimoine, 2004).

4. Charles-Balthazar Févret de Saint-Mémin, "Rapport sur les restes des monuments de l'ancienne chartreuse de Dijon," *Mémoires de la Commission des antiquités de la Côte d'Or* 2 (1842–46): 1–70.

5. Cyprien Monget and Étienne Perrenet, *La chartreuse de Dijon, d'après les documents des archives de Bourgogne.* 3 vols. (Montreuil-sur-Mer: Notre-Dame des Prés, 1898–1905).

6. See Ernest Andrieu, "Histoire des pleurants de Dijon," *Actes du Congrès d'histoire de l'art* (Paris, September–October 1921) (Paris: Presses Universitaires, 1924), 559–63; and "Les tombeaux des ducs de Bourgogne au musée de Dijon," *Bulletin monumental* (1933): 171–93. Also Henri Drouot, "L'atelier de Dijon et l'exécution du tombeau de Philippe le Hardi," *Revue belge d'Archéologie et d'histoire de l'Art* 9 (1932): 11–39; Domien Roggen, "Hennequin de Marville en zijn atelier te Dijon," *Gentsche Bijdragen tot de Kunstgeschiedenis* I (1934): 173–205; and Aenne Liebreich, *Claus Sluter* (Brussels: Dietrich, 1936).

7. Pierre Quarré, *La chartreuse de Champmol: Foyer d'art au temps des ducs Valois,* exh. cat. (Dijon: Musée des Beaux-Arts, 1960) and *Les pleurants dans l'art du Moyen Age en Europe,* exh. cat. (Dijon: Musée des Beaux-Arts, 1971).

8. See the colloquium and exhibition: Association Claus Sluter, *Actes des journées internationales Claus Sluter* (Dijon, September 1990) (Dijon: Association Claus Sluter, 1992). See also Kathleen Morand, *Claus Sluter: Artist at the Court of Burgundy* (Austin: University of Texas Press, 1991); Renate Prochno, *Die Kartause von Champmol: Grablege der burgundischen Herzöge 1364–1477* (Berlin: Akademie Verlag, 2002); the exhibition and catalogue *L'art à la cour de Bourgogne: Le mécénat de Philippe le Hardi et de Jean sans Peur (1364–1419)* (Dijon: Musée des Beaux-Arts in association with the Cleveland Museum of Art; Réunion des musées nationaux, 2004); Michaël Grandmontagne, *Claus Sluter und die Lesbarkeit mittelalterlicher, Skulptur: Das Portal der Kartause von Champmol* (Worms, Germany: Wernersche, 2005); Sherry C. M. Lindquist, *Agency, Visuality and Society at the Chartreuse de Champmol* (Aldershot, England: Ashgate, 2008); Nash, "Claus Sluter's 'Well of Moses' for the Chartreuse de Champmol Reconsidered"; and the Well of Moses colloquium *Autour du Puits de Moïse* organized by Sophie Jugie and Daniel Russo, October 2008 (Dijon: Presses Universitaires de Bourgogne, 2010, forthcoming).

9. The original inscription:

CY GIST TREZ HAULT ET TREZ PUISSANT PRINCE ET FONDEUR DE L'EGLISE DE CEANS, PHILIPPE FILS DE TREZ HAULT ET TREZ EXCELLENT ET PUISSANT PRINCE JEHAN PAR LA GRACE DE DIEU ROY DE FRANCE T DAME BONNE, FILLE DU BON ROY DE BAIGNE, SA COMPAIGNE, DUC DE BOURGOIGNE ET DE LEMBOURG, COMTE DE FLANDRES, D'ARTOIS ET DE BOURGOIGNE, PALATIN, SIRE DE SALINS, COMTE DE NEVERS, DE RETHEL ET DE CHAROLOIS ET SEIGNEUR DE MALINES, QUI TRESPASSA A HALLE EN BRABANT LE XXVIIE JOUR D'AVRIL, L'AN DE GRACE MIL QUATRE CENT ET QUATRE, SI VOUS PLAISE PRIER DIEU DEVOTEMENT POUR SON AME.

10. Drouot, "L'atelier de Dijon et l'exécution du tombeau de Philippe le Hardi."

11. Drouot, "L'atelier de Dijon et l'exécution du tombeau de Philippe le Hardi"; Roggen, "Hennequin de Marville en zijn atelier te Dijon"; Liebreich, *Claus Sluter*; Henri David, *Claus Sluter* (Paris: P. Tisné, 1951); Quarré, *Les pleurants dans l'art du Moyen Age en Europe*; Robert Didier, "Le monument funéraire de Philippe le Hardi, duc de Bourgogne (1342–1404): Jean de Marville, Claus Sluter, Claus de Werve," in Anton Legner, ed., *Die Parler und der schöne Stil 1350–1400: Europäische Kunst unter den Luxemburgern* (Cologne, 1980), vol. 3, 20–23; Fabienne Joubert, "Le tombeau de Philippe le Hardi," in Thomas W. Gaehtgens, ed., *Artistic Exchange / Künstlerischer Austausch: Akten des XXVIII Internationalen Kongresses für Kunstgeschichte Berlin, 15–20 Juli 1992* (Berlin: Akademie Verlag, 1993), vol. 1, 729–39, and "Illusionnisme monumental à la fin du XIVe siècle: Les recherches d'André Beauneveu à Bourges et de Claus Sluter à Dijon," in *Pierre, lumière, couleur: Etudes d'histoire de l'art du Moyen Age en l'honneur d'Anne Prache* (Paris: Presse de l'Université de Paris-Sorbonne, 1999), 367–84; Prochno, "Das Grabmal Philipps des Kühnen für Champmol," in Wolfgang Maier, Wolfgang Schmid, and Michael Viktor Schwarz, eds., *Grabmäler: Tendenzen der Forschung an Beispielen aus Mittelalter und früher Neuzeit* (Berlin: Gebr. Mann Verlag, 2000), 5–102; and Françoise Baron, "Jean de Marville, Claus Sluter et le soubassement du tombeau de Philippe le Hardi," *Bulletin des musées de Dijon*, no. 11 (2010, forthcoming).

12. Pierre Quarré, *Jean de la Huerta et la sculpture bourguignonne au milieu du XVe siècle*, exh. cat. (Dijon: Musée des Beaux-Arts, 1972), and *Antoine le Moiturier: Le dernier des grands imagiers des Ducs de Bourgogne*, exh. cat. (Dijon: Musée des Beaux-Arts, 1973).

13. The mourners depicting clergy members are nos. 41–50, repeating nos. 1–10. The other particularly faithful replicas are nos. 73 (=34), 79 (=39), and 80 (=40).

14. The original inscription:

CY GISSENT TRES HAULT ET TRES PUISSANT PRINCE ET PRINCESSE JEHAN DUC DE BOURGOIGNE COMTE DE FLANDRE D'ARTOIS ET DE BOURGOIGNE PALATIN SEIGNEUR DE SALINS ET DE MALINES FILS DE FEU TRES HAULT ET TRES PUISSANT PRINCE PHILIPPE FILS DE ROY DE FRANCE DUC DE BOURGOIGNE FONDEUR DE CETTE EGLISE ET DAME MARGUERITE DE BAVIERE SA COMPAIGNE LEQUEL DUC JEHAN TRESPASSA LE XE JOUR DE SEPTEMBRE L'AN MCCCCXIX ET LADICTE DAME SA COMPAIGNE LE XXIIIE JOUR DE JANVIER L'AN MCCCCXXIII VEUILLEZ DEVOTREMENT PRIER DIEU POUR LEURS AMES.

15. Quarré, *Les pleurants dans l'art du Moyen Age en Europe*.

16. Béatrice de Chancel-Bardelot, "Le tombeau du duc Jean," *La Sainte-Chapelle de Bourges*, exh. cat. (Paris: Somogy, in association with the Musée du Berry, Bourges, 2004), 126–39.

17. Françoise Baron, Sophie Jugie, and Benoît Lafay, *Les tombeaux des ducs de Bourgogne: De la chartreuse de Champmol au musée des beaux-arts de Dijon, création, destruction, restauration* (Paris: Somogy, 2009).

18. Isabelle Mosneron-Dupin, "Les Trinités en Bourgogne de Jean de Marville à Jean de La Huerta," in *Actes des journées internationales Claus Sluter* (Dijon, September 1990) (Dijon: Association Claus Sluter, 1992), 165–74.

19. Murielle Gaude-Ferragu, *D'or et de cendre: La mort et les funérailles des princes dans le royaume de France au bas Moyen Age* (Lille, France: Presses Universitaires Septentrion, 2005).

20. Emilie Breton, "Les funérailles des ducs de Bourgogne, de Philippe le Hardi à Charles le Téméraire" (master's thesis, University of Rouen, 1996).

21. Transcribed texts relating to the funerals of Philip the Bold, John the Fearless, and Philip the Good in Quarré, *Les pleurants dans l'art du Moyen Age en Europe*, 20–25.

22. On the colors of mourning, see Michel Pastoureau, *Noir: Histoire d'une couleur* (Paris: Editions du Seuil, 2008).

23. Ernest Andrieu, "Les pleurants aux tombeaux des ducs de Bourgogne," *Revue de Bourgogne* (1914): 95–151.

24. Alain Erlande-Brandenburg, *Le roi, la sculpture et la mort: Gisants et tombeaux de la basilique de Saint-Denis*, exh. cat. (Bobigny, France: Archives Départementales de la Seine-Saint-Denis, 1975).

25. Alain Erlande-Brandenburg et al., *Tombeaux royaux et princiers: Dossier archéologie et sciences des origines*, no. 311 (March 2006).

26. Baron, Jugie, and Lafay, *Les tombeaux des ducs de Bourgogne*.

27. Sophie Jugie, "La Salle des Gardes au musée des Beaux-Arts de Dijon ou les avatars d'un panthéon bourguignon," in *Études offertes à Jacques Thirion* (Paris: École Nationale des Chartes, 2001), 287–306.

28. François Gabriel Théodore Basset de Jolimont, *Description historique et critique et vues pittoresques dessinées d'après nature et lithographiées des monuments les plus remarquables de la ville de Dijon* (Paris: A. Barbier, 1830).

Selected Readings on the Chartreuse de Champmol, the Tombs of the Dukes of Burgundy, and the Mourners

Andrieu, Ernest. "Histoire des pleurants de Dijon," *Actes du Congrès d'histoire de l'art* (Paris, September–October 1921). Paris: Presses Universitaires, 1924, 559–63.

———. "Les pleurants aux tombeaux des ducs de Bourgogne," *Revue de Bourgogne* (1914): 95–151.

———. "Les tombeaux des ducs de Bourgogne au musée de Dijon," *Bulletin monumental* (1933): 171–93.

L'art à la cour de Bourgogne: Le mécénat de Philippe le Hardi et de Jean sans Peur (1364–1419) (Art from the Court of Burgundy: The Patronage of Philip the Bold and John the Fearless, 1364–1419). Dijon: Musée des Beaux-Arts in association with the Cleveland Museum of Art; Réunion des musées nationaux, 2004. An exhibition catalogue.

Association Claus Sluter. *Actes des journées internationales Claus Sluter* (Dijon, September 1990). Dijon: Association Claus Sluter, 1992. See especially Anne McGee Morganstern. "Le tombeau de Philippe le Hardi et ses antécédents," 175–91; and Isabelle Mosneron-Dupin. "Les Trinités en Bourgogne de Jean de Marville à Jean de La Huerta," 165–74.

Autour du Puits de Moïse. Colloquium organized by Sophie Jugie and Daniel Russo, October 2008. Dijon: Presses Universitaires de Bourgogne, 2010 (forthcoming).

Baron, Françoise. "Jean de Marville, Claus Sluter et le soubassement du tombeau de Philippe le Hardi," *Bulletin des musées de Dijon*, no. 11, 2010 (forthcoming).

Baron, Françoise, Sophie Jugie, and Benoît Lafay. *Les tombeaux des ducs de Bourgogne: De la chartreuse de Champmol au musée des beaux-arts de Dijon, création, destruction, restaurations.* Paris: Somogy, 2009 (with an extensive bibliography).

Claus Sluter en Bourgogne: Mythe et représentations. Dijon: Musée des Beaux-Arts, 1990. An exhibition catalogue. See especially Monique Richard-Rivoire. "Les tombeaux des ducs de Bourgogne, démontage et restauration," 47–48; and Françoise Baron. "Tombeaux des ducs de Bourgogne: documents figurés antérieurs à la Révolution," 45–46.

David, Henri. *Claus Sluter.* Paris: P. Tisné, 1951.

Didier, Robert. "Le monument funéraire de Philippe le Hardi, duc de Bourgogne (1342–1404): Jean de Marville, Claus Sluter, Claus de Werve," in *Die Parler und der schöne Stil 1350–1400: Europäische Kunst unter den Luxemburgern.* Edited by Anton Legner. Cologne, 1980, vol. 3, 20–23.

Drouot, Henri. "L'atelier de Dijon et l'exécution du tombeau de Philippe le Hardi," *Revue belge d'Archéologie et d'histoire de l'Art* 9 (1932): 11–39.

Févret de Saint-Mémin, Charles-Balthazar. "Rapport sur les restes des monuments de l'ancienne chartreuse de Dijon," in *Mémoires de la Commission des antiquités de la Côte d'Or* 2 (1842–46): 1–70.

Gaal, Elfriede. "Zur ikonographie des Grabmals Philippe le Hardi in Dijon," *Wiener Jahrbuch für Kunstgeschichte* 43 (1990): 7–34.

Gaude-Ferragu, Murielle. *D'or et de cendre: La mort et les funérailles des princes dans le royaume de France au bas Moyen Age.* Lille, France: Presses Universitaires du Septentrion, 2005.

Grandmontagne, Michaël. *Claus Sluter und die Lesbarkeit mittelalterlicher Skulptur: das Portal der Kartause von Champmol.* Worms, Germany: Wernersche, 2005.

Huynh, Michel, Sophie Jugie, and Judith Kagan. *La chartreuse de Champmol et le Puits de Moïse.* Paris: Éditions du Patrimoine, 2004.

Joubert, Fabienne. "Illusionnisme monumental à la fin du XIVe siècle: Les recherches d'André Beauneveu à Bourges et de Claus Sluter à Dijon," in *Pierre, lumière, couleur: Etudes d'histoire de l'art du Moyen Age en l'honneur d'Anne Prache.* Paris: Presse de l'Université de Paris-Sorbonne, 1999, 367–84.

———. "Le tombeau de Philippe le Hardi," *Artistic Exchange / Künstlerischer Austausch: Akten des XXVIII Internationalen Kongresses für Kunstgeschichte Berlin, 15–20 Juli 1992.* Edited by Thomas W. Gaehtgens. Berlin: Akademie Verlag, 1993, vol. 1, 729–39.

Liebreich, Aenne. *Claus Sluter.* Brussels: Dietrich, 1936.

Lindquist, Sherry C. M. *Agency, Visuality and Society at the Chartreuse de Champmol.* Aldershot, England: Ashgate, 2008.

———. *Patronage, Piety and Politics in the Art and Architectural Programs at the Chartreuse de Champmol in Dijon.* PhD diss., University of Illinois, Evanston, 1995; University Microfilms International, Ann Arbor.

Monget, Cyprien, and Étienne Perrenet. *La chartreuse de Dijon, d'après les documents des archives de Bourgogne.* 3 vols. Montreuil-sur-Mer: Notre-Dame des Prés, 1898–1905.

Morand, Kathleen. *Claus Sluter: Artist at the Court of Burgundy.* Austin: University of Texas Press, 1991.

Nash, Susie. "Claus Sluter's 'Well of Moses' for the Chartreuse de Champmol Reconsidered," *The Burlington Magazine* 1, no. 147 (December 2005): 798–809; 2, no. 148 (July 2006): 456–67; 3, no. 150 (November 2008): 724–41.

Les pleurants dans l'art du Moyen Age en Europe. Dijon: Musée des Beaux-Arts, 1971. An exhibition catalogue.

Prochno, Renate. "Das Grabmal Philipps des Kühnen für Champmol," in *Grabmäler: Tendenzen der Forschung an Beispielen aus Mittelalter und früher Neuzeit.* Edited by Wolfgang Maier, Wolfgang Schmid, and Michael Viktor Schwarz. Berlin: Gebr. Mann Verlag, 2000, 5–102.

———. *Die Kartause von Champmol: Grablege der burgundischen Herzöge 1364–1477.* Berlin: Akademie Verlag, 2002.

Quarré, Pierre. *Antoine le Moiturier: Le dernier des grands imagiers des Ducs de Bourgogne.* Dijon: Musée des Beaux-Arts, 1973. An exhibition catalogue.

———. *Jean de la Huerta et la sculpture bourguignonne au milieu du XVe siècle.* Dijon: Musée des Beaux-Arts, 1972. An exhibition catalogue.

———. *La chartreuse de Champmol: Foyer d'art au temps des ducs Valois.* Dijon: Musée des Beaux-Arts, 1960. An exhibition catalogue.

———. *Les pleurants dans l'art du Moyen Age en Europe.* Dijon: Musée des Beaux-Arts, 1971. An exhibition catalogue.

Roggen, Domien. "Hennequin de Marville en zijn atelier te Dijon," *Gentsche Bijdragen tot de Kunstgeschiedenis* 1 (1934): 173–205.